**Essential Skills: Photographic **

Erratum slip

Please refer to p

# photographic lighting

*Essential Skills*

# photographic lighting

john child
mark galer

Focal Press

OXFORD   AUCKLAND   BOSTON   JOHANNESBURG   MELBOURNE   NEW DELHI

Focal Press
An imprint of Butterworth-Heinemann
Linacre House, Jordan Hill, Oxford OX2 8DP
225 Wildwood Avenue, Woburn, MA 01801-2041
A division of Reed Educational and Professional Publishing Ltd

 A member of the Reed Elsevier plc group

First published 1999

**British Library Cataloguing in Publication Data**
A catalogue record for this book is available from the British Library

**Library of Congress Cataloguing in Publication Data**
A catalogue record for this book is available from the Library of Congress

D ISBN 0 240 51549 8     778.72C

Printed and bound in Great Britain

PLANT A TREE

British Trust for Conservation Volunteers

FOR EVERY TITLE THAT WE PUBLISH, BUTTERWORTH-HEINEMANN
WILL PAY FOR BTCV TO PLANT AND CARE FOR A TREE.

# Acknowledgements

Among the many people who have helped make this book possible,
we wish to express our thanks to the following individuals:

Professor Robin Williams and Michael Wennrich for their strong support
for the project.
Sandra Irvine, Roy Cushan and Gunter Bohensky for their help, advice and
input to the final copy.
The students of RMIT University, Melbourne for their illustrative input,
enthusiasm and friendship.
Our families for their love, encouragement and understanding.

# Picture credits

# Contents

# Introduction

Lighting is the essential skill in photography. From the captured image of a fleeting moment using existing light to the highly structured and preconceived advertising image using introduced lighting. This book is intended for students of photography working on location, using primarily the existing light source, and in the studio using artificial light sources. The information, activities and assignments provide the essential techniques for creative and competent photography. The subject guides offer a comprehensive and highly structured learning approach, giving support and guidance to both staff and students. Basic theoretical information is included along with practical advice gathered from numerous professional photographers. An emphasis on useful (essential) practical advice maximises the opportunities for creative photography.

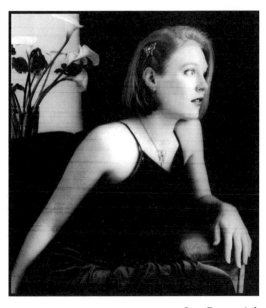 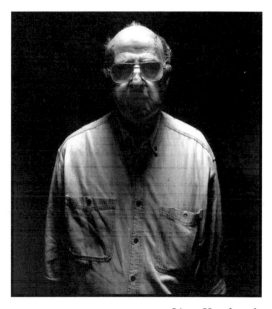

*Lee Rosperich*        *Liam Handasyde*

## Acquisition and application of technique

This book concentrates on the acquisition and application of skills necessary for location and studio lighting. Emphasis is placed on image design, communication of content and the essential techniques required for competent and consistent image capture and creation. The book builds student competence to correctly expose film under difficult lighting conditions. The practical problems of contrast are discussed and additional lighting in the form of tungsten and flash are introduced. Terminology is kept as simple as possible using only those terms in common usage by practising professionals.

Activities and assignments should be undertaken to allow students to express themselves and their ideas through the appropriate application of design and technique.

# Introduction to teachers

This book is intended as an introduction to location and studio photography for full-time students.  The emphasis has been placed upon a practical approach to the subject.

## A structured learning approach

The photographic study guides contained in this book offer a structured learning approach that will give students a framework for working on photographic lighting and the essential skills for personal communication.

The study guides are intended as an independent learning source to help build design skills, including the ability to research, plan and execute work in a systematic manner. Students are encouraged to adopt a thematic approach, recording all research and activities in the form of a Visual Diary and Computation Book.

## Flexibility and motivation

The study guide contains a degree of flexibility often giving students the choice of subject matter.  This allows the student to pursue individual interests whilst still directing their work towards answering specific criteria.  This approach gives the student maximum opportunity to develop self motivation.  It is envisaged that you will introduce each assignment and negotiate the suitability of subject matter with the students.  Individual student progress should be monitored through group meetings and personal tutorials.

## Implementation of the curriculum

For students studying photography full time the information contained in this book, would provide a suitable adjunct to **Essential Skills: Studio Photography** and **Essential Skills: Location Photography** which cover the first and second semesters of the first year.

## Revision exercises

The revision exercises in the study guides should be completed by the student within a specified time determined by a member of staff.  This process will enable the student to organise their own efforts and give them valuable feedback about their strengths and weaknesses.  The revision exercises should be viewed as another activity which the student resources and completes independently whilst being monitored.  Students should then be encouraged to demonstrate the skills and knowledge they have acquired in the process of working through the activities and revision exercises by completion of a self-directed series of projects or all the assignments in the books **Essential Skills: Studio Photography** and **Essential Skills: Location Photography**.

# Introduction to students

The study guides that you will be given during this course are designed to help you learn both the technical and creative aspects of photography.  You will be asked to complete various tasks including research activities and practical assignments.  The information and experience that you gain will provide you with a framework for all your future photographic work.

## Activities and assignments

By completing all the activities and revision exercises in each of the study guides you will learn how other images were created and how to communicate visually.  The images you produce will be a means of expressing your ideas and recording your observations. Photography is a process that is best learnt in a series of steps.  Once you apply these steps to new assignments you will learn how to be creative and produce effective images.

## Using the study guides

The study guides have been designed to give you support during your photography work. On the first page of each study guide is a list of aims and objectives identifying the skills covered and how they can be achieved.

The activities are to be started only after you have first read and understood the supporting section on the preceding pages.  If at any time you are unclear about what is being asked of you, **consult a lecturer**.

## Equipment needed

The course that you are following has been designed to teach you photographic lighting with the minimum amount of equipment.  You will need a camera with manual controls or manual override (if automatic).  You will also need access to flash, tungsten lighting, studio flash, tripod, hand-held light meter and a darkened studio work area.  Large amounts of expensive equipment will not make you a better photographer.  Many of the best photographs have been taken with very simple equipment.  Photography is more about understanding and observing light, and then recreating lighting situations to achieve form, perspective and contrast when working with a two dimensional medium.

## Gallery

At the end of each study guide a collection of student work will appear.  All this work was produced by students working almost exclusively with ambient, flash and tungsten light sources and using colour transparency film.

# Research and resources

To get the best out of each assignment use the activities contained in the study guide as a starting point for your research. You will only realise your full creative potential by looking at a variety of images from different sources. Artists and designers find inspiration for their work in different ways, but most find that they are influenced by other people's work they have seen and admired.

## Getting started

Start by collecting and photocopying images that are relevant to the activity you have been asked to complete. This collection of images will act as valuable resource for your future work. Do not limit your search to photographs. Explore all forms of the visual arts. By using elements of different images you are not copying but using the information as inspiration for your own creative output.

Talking through ideas with other students, friends, family, lecturers or anyone that will listen will help you clarify your thinking and develop your ideas.

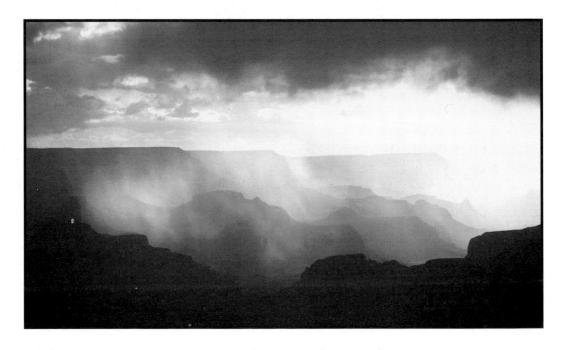

## Choosing resources

When looking for images, be selective. Use only high quality sources. Not all photographs printed are well designed or appropriate. Good sources include high quality magazines and journals, photographic books and exhibitions. You may have to try various sources to find suitable material. Be aware of what exhibitions are coming to your local galleries.

# Visual diary

A Visual Diary is a record of all visual and written stimulus that may have influenced or formed the basis of an idea for the photographic work to be completed.

In its most basic form this could be a scrapbook full of tear sheets (examples) and personal scribbles. It would however be of far more value if your Visual Diary contained more detail relating to an increasing awareness of your visual development in discriminating between good and bad examples of location and studio lighting. This should include design, composition, form and light applicable to any visual art form.

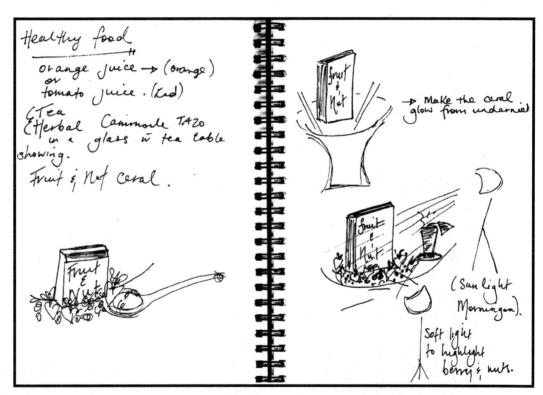

*Joanne Gamvros*

**The Visual Diary should contain:**

~   A collection of work by photographers, artists, writers, filmmakers relevant to your photographic studies.
~   Sketches of ideas for photographs.
~   A collection of images that illustrate specific lighting and camera techniques relevant to studio photography.
~   Brief written notes supporting each entry in the diary.

# Computation book

The Computation Book forms the documented evidence of all the practical considerations and outcomes that are associated with the completion of each activity and assignment.  It should contain comprehensive information that would enable another photographer, who was not present at the original shoot, to reproduce the photograph almost exactly.

**Ball**                  26/03/98
**Film**                  Ektachrome 64T
**Polaroid**              Polapan Pro 100
**Lighting ratio**        Spotlight    f64
                          Floodlight  f45
                          Reflector    f32

**Meter reading**         Incident 2 seconds f45
**Polaroid exposure**     3 seconds f45
**Film exposure**         3 seconds f45
**Process**               Normal

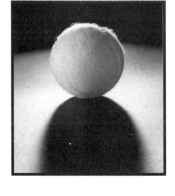

Spotlight from back to create rim light. Floodlight from left, centre of light at point where front of ball falls into shadow. Creates gradual decrease in light across front. White reflector to right side of ball.

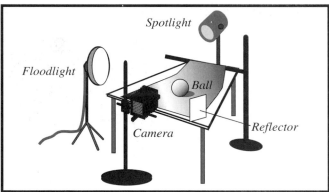

**The Computation Book should contain:**

~   An information sheet for each activity and assignment.
~   Technical requirements and equipment used.
~   Lighting diagram, camera to subject diagram, camera angle and height, (measurements and specifications).
~   Meter readings of light ratios and exposure.
~   Film type, filtration, exposure, processing.
~   Props (use and source) and any other information relevant to each photograph.
~   All Polaroids.
~   Any processed film used to reach the final result should be kept.

# Presentation

## Research

In each assignment you are asked to provide evidence of how you have developed your ideas and perfected the techniques you have been using. This should be presented in an organised way so the assessor can easily see the creative and technical development of the finished piece of work.

Make brief comments about images that have influenced your work. Photocopy these and include them with your research.

## Finished work

Presentation of work will influence your final mark. Design does not finish when the film is processed. If using 35mm film ensure transparencies are slide mounted. If working with a larger format, window mount transparencies in black card. Make sure the window you cut has square corners and is cut with a very sharp blade. Nothing looks worse than a well exposed transparency mounted in a window with ragged edges.

The Computation Book should be word processed and arranged so that is easily understood and submitted with your final folio. Write your name and project title on the back of your work so that it can be returned to you after assessment.

*Viva Partos*

## Storage of work

Assignment work should be kept clean and dry. Use a folder slightly larger than the size of your mounted work. It is recommended that you standardise your final portfolio so that it has an overall 'look' and style. Negatives and transparencies should always be stored separately in appropriate sleeves or sheets, in a dust and moisture-free environment.

# Gallery

RMIT                                    Imogen Barlow

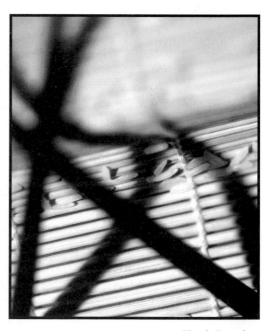

Antonius Ismael                         Hugh Peachey

# Exposure and Light Meters

*Mark Galer*

## Aims

~ To develop knowledge and understanding of exposure and its relationship to film, depth of field and selective focus.
~ To develop an understanding of the use of hand-held and TTL light meters.
~ To understand the difference between reflected and incident meter readings and their relationship to lighting ratios and exposure.

## Objectives

~ **Research** - Produce research in your Visual Diary that shows an understanding of the affect of exposure in the creation of photographic images.
~ **Discussion** - Exchange ideas and opinions with other students and lecturers on the work you are studying.
~ **Practical work** - Produce colour transparencies through close observation and selection that show an understanding of metering techniques and their relationship to exposure and lighting ratios.

# Introduction

An understanding of exposure is without doubt the most critical part of the photographic process. Automatic exposure systems found in many sophisticated camera systems calculate and set the exposure for the photographer. This may lead some individuals to think there is only one correct exposure, when in reality there may be several. The exposure indicated by an automatic system, no matter how sophisticated, is an average. Creative photographers use indicated meter readings for guidance only. Other photographers may interpret the same reading in different ways to create different images. It is essential that the photographer understands how the illuminated subject is translated by exposure into a photographic image.

## Exposure

Exposure is the action of subjecting light sensitive film to light. Cameras and lenses expose film by controlling the intensity of light (aperture) and the duration (time) that is allowed to affect the film. The intensity of light is determined by the size of the aperture in the lens and the duration of light is determined by the shutter.

**Exposure is controlled by aperture and time – intensity and duration.**

Too much light will result in overexposure. Too little light will result in underexposure. It makes no difference whether there is a large or a small amount of light the film still requires the same amount of light for an appropriate exposure.

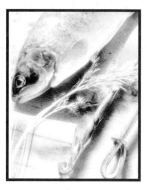 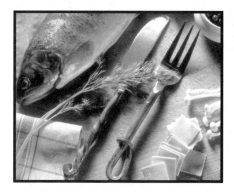 

*Overexposure*                    *Correct exposure*                    *Underexposure*

Film cannot alter its sensitivity to light and adapt to variations in lighting conditions. Exposure has to be adjusted to compensate for these changes. This is achieved by adjusting either the intensity (**aperture**) or duration of light (**time**) entering the camera. An increase in the size of the aperture will give more exposure, a decrease will give less exposure. A decrease in the duration of the shutter speed will reduce exposure, an increase will give more exposure.

# Measuring light

To calculate correct exposure the intensity or level of light has to be measured. Light is measured by a light meter. This study guide deals with the metering techniques of both hand-held light meters and those found in most 35mm cameras and some medium-format cameras (TTL). All light meters give the photographer information about the amount of light available to obtain an appropriate exposure.

The information can be used to set aperture and shutter speed settings in a variety of combinations. Each combination will give different visual outcomes whilst retaining the same overall exposure to the film (depth of field and movement blur).

Working in a creative medium such as photography **'correct exposure'** can sometimes be a very subjective opinion. The photographer may want the image to appear dark or light to create a specific mood.

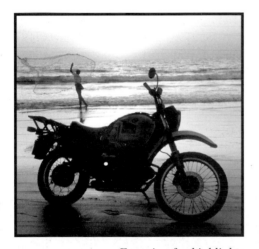

*Exposing for highlights*

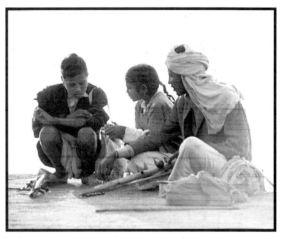

*Exposing for shadows*

# Appropriate exposure

A light meter reading should only be viewed as a guide to exposure. Film is unable to record the broad range of tones visible to the human eye. If the camera frames a subject with highlights and shadows the film may only be able to capture the highlight tones or the shadow tones, not both. An extremely bright tone and an extremely dark tone cannot both record with detail and texture in the same framed image. Underexposure and overexposure in one image is therefore not only possible but common.

It is often necessary for the photographer to take more than one reading to decide on the most appropriate exposure. If a reading is taken of a highlight area the resulting exposure may underexpose the shadows. If a reading is taken of the shadows the resulting exposure may overexpose the highlights. The photographer must therefore decide whether highlight or shadow detail is the priority, change the lighting or reach a compromise. A clear understanding of exposure and film is essential if the photographer is to make an informed decision.

# Intensity and duration

## Intensity

The intensity of light affecting film is controlled by the aperture in the lens.  Actual aperture is the size of the diameter of the iris built in to the camera lens.  The aperture is a mechanical copy of the iris existing in the human eye.  The human iris opens up in dim light and closes down in bright light to control the amount of light reaching the retina.  The aperture of the camera lens must also be opened and closed in different brightness levels to control the amount or intensity of light that reaches the film.

The film requires the right amount of light for correct exposure.  Too much light and the film will be overexposed, not enough light and the film will be underexposed.

As the aperture on the lens is opened or closed a series of clicks can be felt.  These clicks are called f-stops and are numbered.  When the value of the f-stop **decreases** by one stop exactly **twice** as much light reaches the film as the previous number. When the value of the f-stop **increases** by one stop **half** as much light reaches the film as the previous number. The only confusing part is that maximum aperture is the f-stop with the smallest value and minimum aperture is the f-stop with the largest value.

The larger the f-stop the smaller the aperture.  Easy!

f16                    f8                    f4

## Activity 1

Carefully remove the lens from either a small-format or medium-format camera.

Hold the lens in front of a diffuse light source of low intensity.

Whilst looking through the lens notice how the size of the aperture changes as you alter the f-stop.

Record and discuss the relationship between the size of the aperture and the corresponding f-stop number printed on the barrel of the lens.

# Relationship between aperture and f-number

The reasoning behind the values given to the f-stops can be explained by the following example:

~ The diameter of a selected aperture on a standard 50mm lens for a 35mm camera measures 12.5mm.
~ This measurement divides into the focal length of the lens (50mm) exactly four times.
~ The aperture is therefore given the number f4.
~ The diameter of another selected aperture on the same lens measures 6.25mm.
~ This measurement can similarly be divided into the focal length of the lens to give an f-number of f8 thereby explaining why the higher f-numbers refer to the smaller apertures.

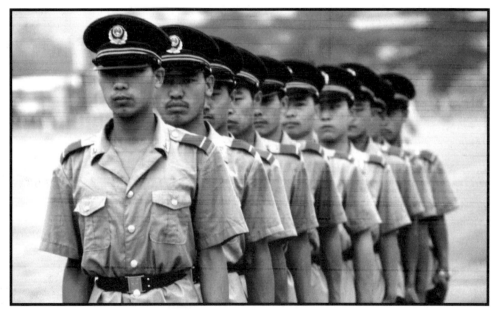

*Beijing*

The diameter of the same f-number may vary for different focal-length lenses but the intensity of light reaching the film plane remains constant. F4 on a long focal-length lens is physically much larger than the same aperture on a shorter focal length lens. The intensity of the light striking the film is the same however due to the increased distance the light has to travel through the longer focal-length lens. See "Inverse square law".

# Activity 2

Take exposure readings of a subject in bright sunlight and in deep shade. Record all of the different combinations of exposure for each lighting condition. Compare the results between a fixed focal length-lens and a zoom lens.

# Duration

The duration of light affecting film is controlled by the shutter.  The time the film is exposed to light is measured in whole and fractions of a second.  This time is regulated by the shutter speed.

Until the invention of the focal plane shutter, exposure time had been controlled by devices either attached to or within the lens itself.  These shutters regulated the length of exposure of the film to light.

Early cameras had no shutter at all and relied upon the photographer removing and replacing a lens cap to facilitate correct exposure times.  Other rudimentary shutters, very similar in appearance to miniature roller blinds, were tried but it was not until the invention of a reliable mechanical shutter that exposure times could be relied upon.

As film emulsions became faster (increased sensitivity to light) so did the opportunity to make shorter exposures.  Within a relatively brief period exposures were no longer in minutes but in fractions of a second.

*1 second*          *1/4 second*          *1/15 second*          *1/60 second*

# The shutter

There are two main types of shutter systems used in photography, the leaf shutter and the focal plane shutter.  The primary function of either system is exposure.  When the shutter is released it opens for the amount of time set on the exposure time dial.  These figures are in whole and fractions of seconds.  The length of time the shutter is open controls the amount of light that reaches the film.  Each shutter speed doubles or halves the amount of light entering the camera.

Leaving the shutter open for a greater length of time will result in a slower shutter speed.  Shutter speeds slower than 1/60 second, using a standard lens, can cause motion blur or camera shake unless you brace the camera or mount it on a tripod.

Using a shutter speed faster than 1/250 or 1/500 second usually requires a wide aperture, more light or a film of increased sensitivity.  These measures are necessary to compensate for the reduced amount of light passing through a shutter open for a short period of time.

**The same exposure or level of illumination can be achieved using different combinations of aperture and shutter speed.  For example, an exposure of f11 @ 1/125 second = f8 @ 1/250 second = f16 @ 1/60 second, etc.**

# Leaf shutter

Leaf shutters are situated in the lens assembly of most medium format and all large format cameras. They are constructed from a series of overlapping metal blades or leaves. When the shutter is released the blades swing fully open for the designated period of time.

# Focal plane shutter

A focal plane shutter is situated in the camera body directly in front of the film plane (where the image is focused), hence the name. This system is used extensively in 35mm SLR cameras and a few medium-format cameras. The system can be likened to two curtains one opening and one closing the shutter's aperture or window. When the faster shutter speeds are used the second curtain starts to close before the first has finished opening. A narrow slit is moved over the film plane at the fastest shutter speed. This precludes the use of high speed flash. If flash is used with the fast shutter speeds only part of the frame is exposed.

The advantages of a focal plane shutter over a leaf shutter are:

~   fast shutter speeds in excess of 1/1000 second.
~   lenses are comparatively cheaper because they do not require shutter systems.

The disadvantage is:

~   limited flash synchronisation speeds.

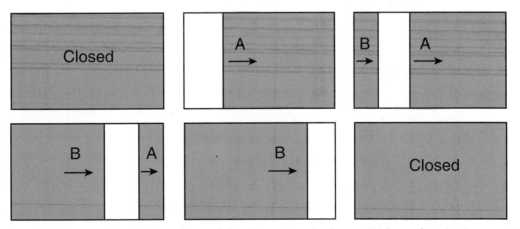

*Focal plane shutter firing faster than the fastest flash synchronisation speed.*

# Activity 3

Load a camera with colour transparency film. Make two exposures at each shutter speed between 1/125 and 1/4 second whilst hand holding a camera. Correct the exposure using the aperture each time the shutter speed is adjusted.
Compare and discuss your results with other students to see who has the least image blur.
Take exposure readings of a subject in bright sunlight and covered shade.
Record all of the different combinations of exposure for each lighting condition.

# Hand-held light meters

Accurate exposure of film is critical to the final quality of the photographic image.  It is therefore essential to have a reliable light meter.  The ability of the human eye to compensate for variations in light, shade and contrast is far greater than any of the film emulsions currently available.  It is difficult to appreciate how the difference between dark and light tones and the balance between different light sources (lighting ratio) will translate into a photographic image without the use of a meter.  Next to a camera the light meter is often considered the most important piece of photographic equipment.  Most 35mm cameras and some medium-format cameras have built in metering systems that measure light reflected from the subject back to the camera.  Although very useful, reflected light meters do not provide information to the photographer about the levels of light falling on the subject.  Photographers requiring this information  need a separate hand-held meter that will measure reflected and incident light.  Without a meter only experience will tell you if there will be detail in the shadows or highlights when the film is exposed.

## Meter readings

Measuring light for the purpose of exposure can be achieved by taking a reflected or an incident reading.

A **reflected reading** is when the light sensitive cell of the meter is pointed at the subject and the light reflected from the subject is measured.

An **incident reading** is when the meter's light sensitive cell is pointed at the camera from the subject and the light falling on the subject is measured.  A white plastic diffuser called an '**invercone'** is placed over the meter's light sensitive cell.  The invercone collects the light from a wide angle of view (180°) and transmits 18% of that light to the meter's cell.

## Meter indicated exposure

The indicated exposure reading is known as the **'meter indicated exposure' (MIE)**.  Although the photographer sees a subject, the meter sees only a level of light.  The meter is calibrated to render everything as a mid-tone regardless of the level of illumination.  A meter will therefore give correct exposure for a man in a grey flannel suit whether he is in a cellar or sunlight.

## 18% grey card

The mid-tone to which all meters are calibrated is called an **'18% grey card',** so called because it reflects 18% of the light falling upon it.  It is an exposure and colour standard manufactured by Kodak.  If a meter reading is taken from any single tone the resulting MIE will render the tone as a mid-tone.  If a  reflected meter reading is taken from a black card the resulting MIE will render the black card grey.  If a reflected meter reading is taken from a white card the resulting MIE will render the white card grey.  This is why snow often comes out grey in many snapshots.

# Interpreting the light meter reading

There are many ways of understanding the information a light meter is giving in relation to exposure. The meter read-out system itself can be confusing. Some photographers refer to EV (exposure value) readings, others t-stops (transmission) and others in zones. All have their merits and it is better to understand one system well than a little about all. In reality they all mean the same. Of all the variations the most common usage is f-stops. All meters usually default to f-stops and all camera lens apertures are calibrated in f-stops. It is important to understand that if the exposure is increased by one stop, either by time or aperture, the amount of light entering the camera has doubled (2X). If increased by two stops the amount of light has doubled again (4X). If increased by three stops the light doubles again (8X) and so on. This simple law applies with the opposite result to decrease in exposure. It is also important to remember to set the meter to the ISO rating (measure of film sensitivity to light) that applies to the film you are using See **"Film"**.

# Average exposure

Most films are able to record a full range of tones if the lighting is even. In most situations where the tones are evenly distributed the most appropriate exposure is often the average indicated by the light meter. When light or dark tones dominate however, underexposure or overexposure may occur as the average exposure is no longer appropriate. It is essential the photographer understands how the light meter reads light to have full control over the exposure.

# Activity 4

Using a diffuse light source (floodlight) take individual reflected light meter reading of three pieces of card. One white, one black and one mid-grey.

Adjust the angle of the card to avoid specular reflections (the card should not appear shiny).

The black card should give a reading that is different by four stops to the reading off the white card. The mid-grey card should be between the two. If the mid-grey card is two stops apart from each, you have a mid-tone that the meter sees as the average tone (18% grey).

Using tungsten transparency film make one exposure of each of the three cards using the MIE of each card.

Photograph the white and black cards again using the MIE of the grey card.

Label the results with the meter indicated exposure, the actual exposure and the tone of the card being photographed.

Discuss and compare results with other students.

# Taking a hand-held meter reading

## Incident reading

For an incident reading it is important to place the white plastic dome supplied with the meter over the light-sensitive cell.  This is called an **'invercone'**.  The purpose of the invercone is to diffuse the light falling on the subject from a wide angle of acceptance (180°) and transmit 18% of that light. The sensitivity or ISO of the film must then be dialled into the meter.  The light meter is generally taken to the subject and the light-sensitive cell is directed back towards the camera.  The reading may default to EV (exposure value) which can be interpreted or changed to an aperture/shutter speed combination.  On modern digital meters the photographer is able to pre-select a particular shutter speed or aperture and have the meter indicate the corresponding value to obtain correct exposure.

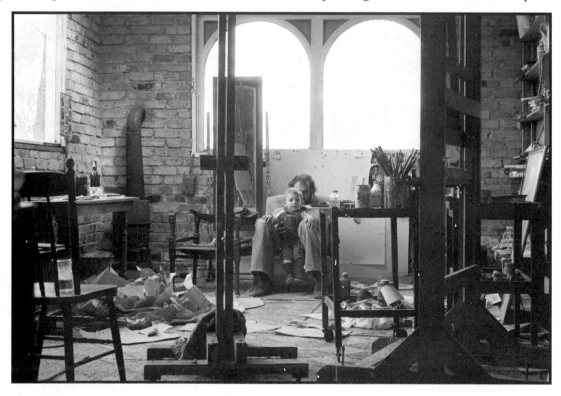

*John Child*

## Activity 5

Take an incident light reading of a subject in a constant light source.
Note the f-stop at an exposure time of 1/8 second.  Increase the number of the aperture by three f-stops. Note the change in exposure time.
Discuss with other students what the result would be if the duration of time had been increased by a factor of three instead of the aperture.

# Reflected reading

For a reflected reading it is important to remove the invercone from the light-sensitive cell. The meter's cell has an angle of acceptance equal to a standard lens (with a spot meter attachment the angle can be reduced to five degrees or less for precise measurements). The film's ISO is dialled into the meter. The meter is pointed **towards** the subject.

The exposure the meter recommends is an average of the reflected light from the light and dark tones present. When light and dark tones are of equal distribution within the field of view this average reading is suitable for exposure. It must be remembered the meter measures only the level of light. It does not distinguish between dark or light tones. If a reading is taken from a single tone the light meter will always indicate an exposure suitable to render this tone as a mid-tone. If the subject is wearing a grey flannel suit a reflected reading from the camera would give an average for correct exposure. However, if the subject is wearing a white shirt and black jeans a reflected reading of the shirt would give an exposure that would make the shirt appear grey on film. A reflected reading of the jeans would make them appear grey on film. When light or dark tones dominate the photographer must increase or decrease exposure accordingly.

## General reflected reading

If the reading is taken from the camera position a general reading results. This general reading is an average between the reflected light from the light and dark tones present. When light and dark tones are of equal distribution within the frame this average light reading is suitable for exposing the subject. When light or dark tones predominate in the image area they overly influence the meter reading and the photographer must increase or decrease exposure accordingly.

## Specific reflected reading

A more accurate reading can be taken when light or dark tones dominate the scene by moving the light meter closer to a mid-tone. This avoids the meter being overly influenced by these tones. Care must be taken not to cast your own shadow or of the meter when taking a reading from a close surface.

If the photographer is unable to approach the subject being photographed, it is possible to take a meter reading from a tone close to the camera. A useful technique is to take a reading from a grey card angled to reflect the same light as the subject or of Caucasian skin.

*Specific reflected reading - Tim Roberts*

# TTL light meters

'Through the lens' (TTL) light meters built into cameras, measure the level of reflected light prior to exposure.  They measure only the reflected light from the subject matter within the framed image.  The meter averages or mixes the differing amounts of reflected light within the framed image, and indicates an average level of reflected light.  The light meter readings are translated by the camera's CPU and used to set aperture and/or shutter speed.

## Centre-weighted and matrix metering

Centre-weighted and selective metering systems (matrix metering), common in many cameras, bias the information collected from the framed area in a variety of ways.  Centre-weighted metering takes a greater percentage of the information from the central area of the viewfinder.  The reading, no matter how sophisticated, is still an average - indicating one exposure value only.  Any single tone recorded by the photographer using a TTL reading will reproduce as a mid-tone, no matter how dark or light the tone or level of illumination.  This tone is the midpoint between black and white.  If the photographer takes a photograph of a black or white wall and uses the indicated meter reading to set the exposure, the final image produced would show the wall as having a mid-tone.

*Centre-weighted TTL metering.*

## Automatic TTL exposure modes

If the camera is set to fully automatic or programme mode both the shutter speed and aperture will be adjusted automatically ensuring correct exposure.  In low light the photographer using the programme mode should be aware of the shutter speed being used to achieve correct exposure.  As the lens aperture reaches its widest setting the programme mode will start to use shutter speeds slower than those usually recommended to avoid camera shake.  Many cameras alert the photographer to this as an audible signal.  This should not be treated as a signal to stop taking photographs but to take precautions to avoid camera shake, such as bracing the camera  or using a tripod.

# Semiautomatic

The disadvantage of a fully automatic or programme mode is that it can often take away the creative input the photographer can make to many of the shots. A camera set to fully automatic is programmed to make decisions which are not necessarily correct in every situation.

If your camera is selecting both the aperture and shutter speed you may like to consider spending some time finding out how the camera can be switched to semiautomatic and manual operation.

Semiautomatic exposure control, whether aperture priority (Av) or shutter priority (Tv) allows creative input from the photographer (see "Depth of field" and "Movement blur") but still ensure MIE is obtained automatically.

# Aperture priority (Av)

This is a semiautomatic function where the photographer chooses the aperture and the camera selects the shutter speed to achieve MIE. This is the most common semiautomatic function used by professional photographers as the depth of field is usually the primary consideration. The photographer using aperture priority needs to be aware of slow shutter speeds being selected by the automatic function of the camera when selecting small apertures in low-light conditions. To avoid camera shake and unintended blur the aperture has to be opened and the depth of field sacrificed.

*Elinor McRae*                                    *John Child*

# Shutter priority (Tv)

This is a semiautomatic function where the photographer chooses the shutter speed and the camera selects the aperture to achieve correct exposure. In choosing a fast shutter speed the photographer needs to be aware of underexposure when the light levels start to decrease. The fastest shutter speed possible is often limited by the maximum aperture of the lens. In choosing a slow shutter speed the photographer needs to be aware of overexposure when photographing brightly illuminated subject matter. Movement blur may not be possible when using fast film in bright conditions.

# Interpreting the meter reading

The information given by the light meter after taking a reading is referred to as the **'meter indicated exposure' (MIE).** This is a guide to exposure only. The light meter should not be perceived as having any intelligence or creative sensibilities. The light meter cannot distinguish between tones or subjects of interest or disinterest to the photographer. It is up to the photographer to decide on the most appropriate exposure to achieve the result required. A photographer with a different idea and outcome may choose to vary the exposure. It is the photographer's ability to interpret and vary the meter indicated exposure to suit the mood and communication of the image that separates their creative abilities from others.

If light or dark tones dominate, the indicated exposure will be greatly influenced by these dominant tones. Using the MIE will expose these dominant dark or light tones as mid-tones. Minority light and mid-tones will be overexposed or underexposed. If you consider interest and visual impact within a photograph is created by the use of lighting and subject contrast (amongst many other things) the chances of all the elements within in the frame being mid-tones are remote. The information, mood and communication of the final image can be altered through adjusting exposure from MIE.

## Average tones

A subject of average reflectance (mid-tone) is placed with equal dark and light tones. All three tones are lit equally by the same diffuse light source.

A reflected reading of the mid-tones will give correct exposure. An exposure using the reflected reading of the dark tone will render it grey and overexpose the mid and light tones. An exposure using the reflected reading of the light tone will render it grey and underexpose the mid and dark tones.

An incident reading will give 'correct' exposure regardless of which tone it is held in front of because it measures the light falling on the subject, not the light reflected from it. The intensity of the light source is constant but the reflected light from the three tones varies.

## Activity 6

In a constant light source take a reflected light reading with a hand-held meter from 30cm of an 18% grey card. Note the exposure reading.

Now take an incident reading from the grey card with the invercone pointing back towards where you were standing when you took the reflected reading. Note the exposure readings.

Expose a subject with dominant mid-tones in both bright and dull illumination using the MIE. Keep a record of both exposures and label the results. Discuss the similarities and differences of each image.

# Dominant dark tones

A subject of average reflectance (mid-tone) is photographed with dominant dark tones. All three tones are lit equally by the same diffuse light source. A reflected light meter reading is taken from the camera. The dominant dark tones reflect less light than 18% grey so the meter indicates an increased exposure compared to a meter reading taken from a mid-tone. The MIE, if used, will result in the dark tones becoming mid-tones and the mid-tones overexposing. If the tones are to be recorded accurately the exposure must be reduced (less time or less light) from that indicated. The amount of reduction is dictated by the level of dominance of the dark tones.

An incident reading will give 'correct' exposure regardless of which tone it is held in front of because it measures the light falling on the subject, not the light reflected from it. The intensity of the light source is constant but the reflected light from the tones varies.

*Dominant dark tones - RMIT*

*Dominant light tones - RMIT*

# Dominant light tones

A subject of average reflectance (mid-tone) is photographed with dominant light tones. All the tones are lit equally by the same diffuse light source. A reflected light meter reading is taken from the camera. The dominant light tones reflect more light than 18% grey so the meter indicates a decreased exposure compared to a meter reading taken from a mid-tone. The MIE if used will result in the light tones becoming mid-tones and the mid-tones underexposing. If the tones are to be recorded accurately the exposure must be increased (more time or more light) from that indicated. The amount of increase is dictated by the level of dominance of the light tones.

An incident reading will give 'correct' exposure regardless of which tone it is held in front of because it measures the light falling on the subject, not the light reflected from it. The intensity of the light source is constant but the reflected light from the tones varies.

## Activity 7

Photograph two subjects that require adjusted exposure from that indicated by the light meter. State how the dominant tones would have effected the light meter reading and how the image would have looked if you had not adjusted the exposure.

# Revision exercise

Q1.   True or false?  Maximum aperture = f22, minimum aperture = f2.8.

Q2.   If the exposure meter reading indicates an exposure of 1/60 second @ f8 what would be the correct aperture if the shutter speed was changed to 1/8 second?

Q3.   Changing exposure from f4 @ 1/60 second to f11 @ 1/30 second has increased or decreased the exposure?

Q4.   A reflected reading measures the light reflecting from a subject.  What does an incident reading measure?

Q5.   Will increasing the exposure give more detail in the highlights or shadows?

Q6.   What degree of increased exposure from a reflected light meter reading would you expect to have to use when photographing snow coloured ski fields that are receiving full illumination from the midday sun?

Q7.   A photographer uses Caucasian skin to establish an exposure reading for a mid-tone.  What adjustment should be made to the MIE to correctly expose for the mid-tone?

Q8.   Name two advantages of the focal plane shutter compared to a leaf shutter.

Q9.   What is a general reflected reading?

Q10.  How does this differ from an incident reading of the same subject?

# Resources

*Advanced Photography - Michael Langford.*  Focal Press. London. 1997.
*American Cinematographer Manual.*  ASC Press. Hollywood. 1993.
*Basic Photography - Michael Langford.*  Focal Press. London. 1997.
*Black and White Photography - Rand/Litschel.*  West Publishing Co. Minneapolis. 1994.
*Essential Skills: Studio Photography - John Child.*  Focal Press. London. 1999.
*Essential Skills: Location Photography - Mark Galer.*  Focal Press. London. 1999.
*Kodak Professional Products.*  Kodak (Australasia) Pty. Ltd. Melbourne. 1998.
*Light Science and Magic - Fil Hunter and Paul Fuqua.*  Focal Press. Boston. 1997.
*Photographing in the Studio - Gary Kolb.*  Brown & Benchmark.. Wisconsin. 1993.
*Photography - Barbara London and John Upton.*  Harper Collins. New York. 1994.
*The Focal Encyclopedia of Photography.*  Focal Press. London. 1993.

# Gallery

*John Child*

*Chloe Paul*

# Gallery

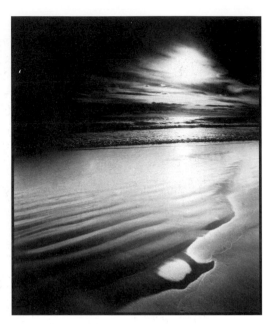

*RMIT*

*Michael Wennrich*

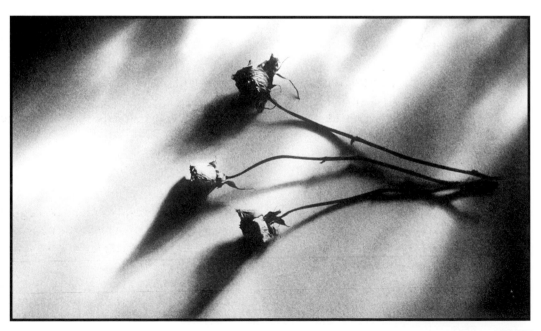

*RMIT*

# Film

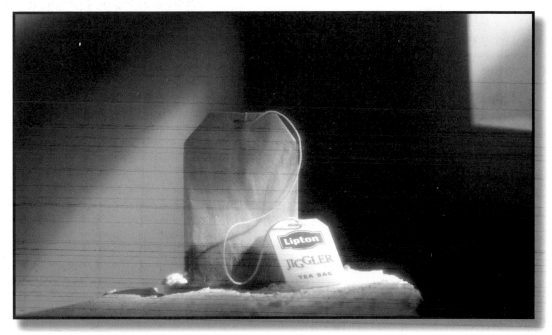

*Soek Jin Lee*

## Aims

~ To develop knowledge and understanding of colour film and Polaroid
  materials available to the photographer.
~ To develop an understanding of the use of these materials, their advantages,
  limitations and processing.

## Objectives

~ **Research** - Produce a Visual Diary that shows several different photographs,
  and the techniques employed by the photographer to achieve the result.
~ **Discussion** - Exchange ideas and opinions with lecturers and other students on the
  work you are studying.
~ **Practical work** - Produce photographic transparencies through the use of technique,
  observation and selection that demonstrate a practical understanding of film.

# Introduction

There is an overwhelming range of colour and black and white films available for the professional and amateur photographer. Choosing the appropriate film for the job is an essential skill for every photographer.

## Film type

Film can be divided into three main types:

~   Black and white negative
~   Colour negative
~   Colour transparency (positive or slide film)

Colour negative and colour transparency films are easily and quickly distinguished in the shops by a number of identifying labels.  Films ending with the suffix 'chrome' e.g. Kodachrome, Fujichrome  are transparency films.  Film names ending with the suffix 'color' are negative films e.g. Fujicolor, Kodacolor.
Film boxes will indicate the type of processing required for the film.  C-41 indicates the film is a colour negative film whilst E-6 indicates the film is a transparency reversal film. E-6 processing is usually not carried out by high street mini-labs.

*Relative size of formats*

*Relative shape of formats*

## Film format

Each of these main types of film is available in the following formats:

~   35mm
~   120 roll film
~   4" x 5" sheet film

120 roll film is suitable for the entire range of medium format cameras from the smaller 6 x 4.5cm cameras to the popular 6 x 6cm and 6 x 7cm cameras through to the specialist panoramic cameras shooting frames as wide as 6 x 17cm.

# Positive or negative

Colour or black and white film fall into two main categories.

A positive film emulsion will give you, within its limitations, an image that is exactly what the camera saw. Commercial photography reproduced in magazines as advertisements or editorial is predominantly produced on reversal (transparency) film.

The advantage of reversal film is that it is a one-step process to achieve a positive image. A negative film emulsion will give you, again within its limitations, an image that is the opposite of what the camera saw. The highlights will be dark, shadows will be light, and colours will appear as their complementary. Red will appear cyan, green will appear magenta, blue will appear yellow and so on (coupled with the fact all these colours are transmitted through an orange film base). It is only when a negative is printed that it becomes a positive image.

The advantage of negative film is its greater '**latitude**' and ability to handle higher subject contrast levels than positive film.

## Processing

Colour film processing should be undertaken by a professional laboratory. Although it is possible to purchase chemicals to process colour film the money saved may well be a false economy when considering the experience and equipment required to produce consistent and accurate colour processing.

Colour transparency film is processed using the E-6 process. This is a Kodak processing system and will process nearly all colour positive films.

Colour negative film is processed using the C-41 process. This is also a Kodak processing system and will process nearly all colour negative films.

The number of black and white processing systems are as varied as the number of films available. Although not covered in this book it is recommended all photographers develop a thorough understanding of black and white processing. It is relatively simple technology (it has changed little since its introduction) and easy to learn.

## Appropriate exposure

Assessing correct exposure of the processed film can be achieved by viewing the film on a light box or by transmitted light (where the light passes through the film). It takes practice to be precise about the subtleties of underexposure and overexposure but there is a simple starting point. If there is no image detail something is wrong.

If negative film appears 'dense' (transmits very little light) with no visible detail it is probably **overexposed**.

If positive film appears 'dense' it is probably **underexposed**.

If negative film appears 'thin' (transmits nearly all light) with no visible detail it is probably **underexposed**.

If positive film appears 'thin' (transmits nearly all light) it is probably **overexposed**.

# Transparency film

Colour transparency film can be further subdivided:

~ Professional or general purpose
~ Tungsten or daylight

## Professional film

Professional film is made to the highest quality-control procedures.  The film material is more consistent between batches than the equivalent general purpose film and is essential when speed or colour variations cannot be tolerated.  Professional film should only be purchased if it has been stored in a refrigerator.  The increased price for professional film is not warranted on many jobs that the photographer undertakes.

## Tungsten and daylight

Tungsten film is only available as professional film and is distinguished by the letter 'T' after the ISO rating.  It is available in three ISO ratings and is generally used for commercial studio applications.  Many photographers refer to the film by its prefix letters e.g. EPY, EPT and EPJ are current examples.

Most transparency film is balanced for daylight (5500K).  Colour film can only achieve correct colour balance when it is used with the appropriate light source.  It is possible however to achieve interesting results by using a film with an incorrect light source.  If a daylight film is used with tungsten light a very warm sepia effect is obtained.  If tungsten film is used with a daylight source a cold blue effect will be the result.  In both cases the ISO will change resulting in variations to exposure.

| **Tungsten** | | |
| --- | --- | --- |
| **ISO** | **FORMAT** | **PROCESS** |
| 64 | Small, medium, large | E-6 |
| 160 | Small, medium | E-6 |
| 320 | Small | E-6 |
| **Daylight** | | |
| **ISO** | **FORMAT** | **PROCESS** |
| 64 | Small, medium, large | E-6 |
| 100 | Small, medium, large | E-6 |
| 200 | Small | E-6 |
| 400 | Small, medium | E-6 |

# Film characteristics

All films share the following characteristics:

~ Speed (sensitivity to light)
~ Grain and resolution (sharpness)
~ Contrast

## Speed

All film is given an ISO (International Standards Organisation) rating. This rating indicates its sensitivity to light. The higher the rating the greater the sensitivity to light.

ISO is a combination of two previous rating systems, the American ASA rating and the European DIN rating. The ISO rating of a specific film is made up of two separate numbers e.g. 400/27°. The first number is the ASA value and the second is the DIN. It is usual for photographers to refer to a film only by the first number.

Films are available from 25 ISO to 3200 ISO. Each time the ISO doubles the film is twice as light sensitive e.g. a 400 ISO film requires only half the exposure of a 200 film. The 400 film can therefore be said to be one stop faster than a 200 ISO film and two stops faster than a 100 ISO film. Films are often referred to as slow, medium or fast. A film is described as being slow if its ISO is 64 or less and fast if its ISO is 400 or more.

The advantage of using fast film is that a photographer is able to use faster shutter speeds to either freeze action or avoid camera shake. The disadvantage of using faster film is its decreased resolution or sharpness and the increased size of grain.

## Grain and resolution

Just as a computer image is made up of a series of pixels or picture elements the silver image on a roll of film is made up from a grain pattern (a range of dots). As the ISO increases the size of the grain increases. The grain pattern becomes apparent when the image is enlarged. As the image is enlarged it appears progressively less sharp. An image created using slow speed film will enlarge to a greater physical size before the sharpness becomes unacceptable than if the same image was created using a fast speed film. Reduced grain size is a strong selling point for fast films.

## Contrast

As the ISO rating increases the contrast of the film decreases. The slower the film the higher the contrast. Many people get confused over this point because when film is '**pushed**' (increasing the recommended speed of the film and the processing time) the contrast increases. This is a result of the processing however and not the film speed that was used to expose the film. High contrast film is not easy to use with high contrast subject matter. If the photographer is not skilled with this combination information in the highlights and shadows is usually lost.

# Using film

## Expiry date

At the time of manufacture all film products have an expiry date printed on their packaging. Do not use film once this date expires. The manufacturer will not guarantee correct rendition of colour and reliable results cannot be predicted. Store unexposed film at a constant temperature, preferably in a refrigerator, but **do not** freeze.

## Colour temperature

Colour temperature is a measure of the colour of light. Colour temperature is described in terms of degrees Kelvin (K). This simply refers to a temperature scale similar to Fahrenheit or Celsius. It is not important to fully understand the theory of colour temperature other than to know that certain colour films are used with certain artificial lights. Black and white film is relatively unaffected by colour temperature.

**Tungsten film is rated at 3200K and used with tungsten lighting.**
**Daylight film is rated at 5500K and used with flash and daylight.**

To render correct colour, filtration can be used to balance any film to any lighting situation. The filtration required is listed in the manufacturer's specifications packaged with the film.

## Reciprocity

Reciprocity, more correctly referred to as reciprocity failure, is a measure of the films ability or inability to handle extreme exposure times. Reciprocity, in general terms, takes effect when shutter speeds are greater than 1 second when using daylight colour film, greater than 30 seconds when using tungsten colour film and 1 second when using black and white. All manufacturers issue a technical information sheet with their professional film packaging stating the reciprocity values relevant to that batch (manufacturing identification) of film. This should be followed closely.

Without going into the causes of reciprocity the remedy is to reduce shutter speed (time) and compensate by increasing aperture (intensity). Increasing exposure by increasing time will only compound the problem.

The results of not compensating for reciprocity is an underexposed image, varying shifts in colour rendition and unpredictable results.

## Activity 1

Using colour transparency film photograph a subject of average contrast.
Adjust exposure (increase aperture) so exposure times start at 1 second.
In one stop increments increase exposure time to 64 seconds.
Process the film and label the results for reference, comparison and discussion.
At what exposure time did the film you chose suffer reciprocity failure?

# Latitude

Latitude is a measure of the ability or inability to record detail in subjects with extreme contrast and variation from correct exposure.

It is an accepted rule that most modern film emulsions have a approximate five to seven stops latitude, although this is sure to increase as manufacturers develop new technology. This means that if you underexposed an 18% grey card by three stops it would appear black on the processed film. If you overexposed it by three stops it would appear white. The human eye has almost limitless latitude because of its ability to compensate for changes in contrast and light levels. Film is incapable of doing this due to its limited latitude.

Black and white and colour negative film have a latitude of seven stops and can handle a contrast ratio of 128:1. Colour transparency with five stops latitude can handle a contrast ratio of 32:1. The human eye is capable of adjusting to a ratio in excess of 1000:1.

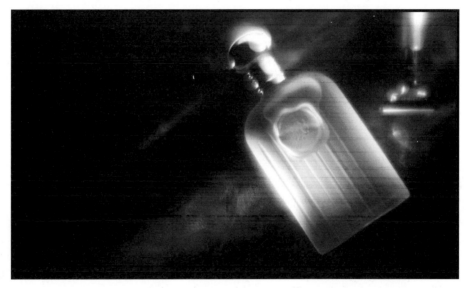

*RMIT*

# Activity 2

Load a camera with colour transparency film.
Light a grey card with a diffuse tungsten light source.
Make sure the card fills the frame.
De-focus the camera.
Take a reflected or incident meter reading.
Either side of correct exposure, overexpose and underexpose in sequence one to five stops.
Process the film and evaluate the results.
Discuss and compare with other students' results the point at which the film is unable to record detail above and below correct exposure (latitude).
This will indicate the film's latitude and indicate the limit of the film's ability to cope with incorrect exposure.

# Push and pull

A safety net that all photographers can use is the manipulation of processing after exposure of the film.  This applies to all film materials.  Despite the precision of the camera and metering systems used, human error can still occur when taking a photograph.

If the situation allows bracketing (exposure one and two stops either side of and including normal) is a way of ensuring correct exposure.  When there is not the opportunity to bracket exposure and all exposures are meter indicated exposure (MIE) it is advisable to clip test the film.

## Clip test

Clip testing is a method of removing the first few frames from an exposed roll of film and processing as normal (i.e. to manufacturers specifications).  If these frames appear underexposed, a push process (over processing the film) may improve or compensate for any error in exposure.  If overexposure is evident a pull process (under processing) may correct the result.

The amount of pushing or pulling required to produce an acceptable result is generally quantified in stops.  If an image appears underexposed by one stop push the film one stop.  If an image appears overexposed one stop pull the film one stop.

Push processing colour transparency that has correct exposure is also an option.  It has the affect of cleaning up the highlights and giving an appearance of a slight increases in contrast.  Pushing in excess of what would be required to achieve this can be an interesting exercise.  The results can be unpredictably dramatic.

Most professional film processing laboratories offer this service.

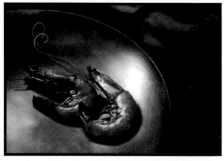

*Normal process*                    *One stop push*

# Activity 3

Load a camera with colour transparency.

Deliberately underexpose by one and two stops subjects with average contrast.

Clip test the film - normal process.  Clip test again - one stop push.

Clip test again- two stop and three stop push.

Assess the result and process the rest of the film at processing levels you determine.

Keep a record of the results for reference.

# Cross processing

Similar to over and under processing is the practice of processing a film in chemicals different to that suggested by the manufacturer.

If a transparency film normally processed E-6 is instead processed C-41 (colour negative) the result is quite different to what would be expected. The result is a transparency with negative colours and tones.

Matching a film to an incorrect process can be done in any combination but the results can vary from amazing to very disappointing, but well worth the experimentation.

It is important to note film speed changes when cross processing. As a general rule transparency film should be under exposed by one stop when processing in C-41, and negative film over exposed by one stop. This is only a guide and variations in film speed and processing should be tested to obtain the result you want.

*Colour transparency - process C-41*
*Kathryn Marshall*

# Activity 4

With another student photograph the same subjects of varying contrast (high to low) onto two rolls of colour transparency.

Bracket the exposures and keep a record of aperture and time.

Process one film E-6 and the other C-41.

Label the results for reference, comparison and discussion.

# Polaroid

Since its introduction in 1946 Polaroid materials have become a common tool in the assessment of exposure, contrast, composition and design.  To most people, whether it be you, a lecturer, an art director or someone wanting a family portrait it is the first evidence of the photographic process and an indicator of where improvements can be made. Polaroid has become 'the rough drawings' on the way to the final photograph.

All Polaroid materials, colour or black and white will give a positive image.  In some cases a negative, as well as a positive, will be produced that can be printed in the normal way at a later date.

When using Polaroid follow the instructions relating to film speed (ISO or ASA) closely and observe the processing times relating to room temperature.  It is important processing times are followed carefully.

When assessing a Polaroid for exposure relative to a another film type it should be realised that more detail will be seen in a correctly exposed colour transparency than will be seen in the Polaroid's positive reflection print.  This is because transparencies are viewed by transmitted light and prints by reflected light.  The Polaroid will appear 'thin' if it is over exposed and 'dense' if it is under exposed.  Types of Polaroid film suitable for this subject are listed below.

## Tungsten

| TYPE | ISO | FORMAT |
|---|---|---|
| Polacolor 64 Tungsten | 64 | 3 1/4 x 4 1/4<br>4 x 5 |
| Polapan Pro 100 | 64 | 3 1/4 x 4 1/4<br>4 x 5 |

## Daylight

| TYPE | ISO | FORMAT |
|---|---|---|
| Polacolor Pro 100 | 100 | 3 1/4 x 4 1/4<br>4 x 5 |
| Polapan Pro 100 | 100 | 3 1/4 x 4 1/4<br>4 x 5 |

## Activity 5

Using a diffuse tungsten source light a persons hand.  Correctly expose by incident reading onto Polaroid Pro 100 rated to the appropriate ISO for tungsten.

Repeat onto colour transparency (64 ISO) using Polaroid as your means of determining exposure and composition.

# Revision exercise

Q1.    Colour reversal film gives a positive or negative image?

Q2.    Tungsten transparency film will give correct colour when used with which light source?

Q3.    What is the colour temperature of that light source?

Q4.    The exposure for film rated at ISO 100 is 1/15 second @ f8.
       What will the exposure be for film rated at ISO 400 if aperture remains constant?

Q5.    What is the most likely affect of using out of date colour film?

Q6.    What is the relationship between a film's latitude and exposure?

Q7.    Processing reversal film in a negative process will give what result?

Q8.    If a processed negative film is almost totally clear is it over or underexposed?

Q9.    Push processing film can be used when the film is over or underexposed?

Q10.   Which has the greater latitude, colour negative or colour reversal film?

# Resources

*American Cinematographer Manual.* ASC Press. Hollywood. 1993.
*Basic Photography - Michael Langford.* Focal Press. London. 1997.
*Encyclopedia of Photography.* Crown Publishers. New York. 1984.
*Essential Skills: Studio Photography - John Child.* Focal Press. London. 1999.
*Essential Skills: Location Photography - Mark Galer.* Focal Press. London. 1999.
*Focal Encyclopedia of Photography.* Focal Press. London. 1993.
*Kodak Professional Products.* Kodak (Australasia) Pty. Ltd. Melbourne. 1998.
*Light Science & Magic - Fil Hunter & Paul Fuqua.* Focal Press. Boston. 1997.
*Photographing in the Studio - Gary Kolb.* Brown & Benchmark. Wisconsin. 1993.
*Photography - Barbara London and John Upton.* Harper Collins. New York. 1994.
*Polaroid Professional Film Guide.* Polaroid Australia Pty. Ltd. Sydney. 1998.

# Gallery

*Tori Costello*

*Tetsuharu Kubota*

# Filters

*Mark Galer*

## Aims

- ~ To develop knowledge and understanding of photographic filters available to the studio and location photographer.
- ~ To develop an understanding of the appropriate application of filters to modify light for the purpose of appropriate exposure and visual effect.
- ~ To develop a basic understanding of colour theory.

## Objectives

- ~ **Research -** Produce work in your Visual Diary that illustrate different filtration techniques employed by photographers working in the studio and on location.
- ~ **Discussion -** Compare and contrast photographic work you are producing with lecturers and other students.
- ~ **Practical work -** Produce colour transparencies and black and white prints through the use of technique, observation and selection that demonstrate a practical understanding of filtration.

# Introduction

The purpose of a filter is to selectively modify the light used to expose the film. Filters are used by all professional photographers. They are an indispensable means of controlling the variations in light source that the photographer is likely to encounter or use.

The range of filters used varies according to the range of situations likely to be encountered.

## Studio

In the studio the photographer is able to create images with a consistent quality using few, if any, filters so long as the film stock is carefully matched to the light source being used. The studio photographer has the option of filtering the light source, the camera lens or placing the filters between the lens and the film plane. If the photographer is using a mixture of light sources the photographer should ideally filter the light at its source. Any filter attached to the camera lens must be of premium quality - preferably glass.

## Location

On location where ambient light is the primary light source or cannot be eliminated from the overall exposure the necessity to carry and use a broad range of filters increases.

If choosing to purchase filters for lenses the photographer needs to be aware of the thread size on the front of each lens intending to be used. Filter sizes for fixed focal length, wide angle and standard lenses on 35mm cameras are usually between 48 to 55mm. Medium format, telephoto and zoom lenses may have thread sizes much larger. Purchasing every filter for every lens would be an expensive operation, so filters have to be selected carefully through actual rather than perceived need.

Plastic filters are available from manufacturers such as 'Cokin' which can be adapted to fit a range of different lens diameters. The initial outlay of money to filter all the lenses owned by the photographer can be greatly reduced, but their working life may be far less because the risk of damage is far greater. The decision must be left to the individual photographer.

## Basic colour theory

To be comfortable with filtration it helps to understand basic colour theory. The broad spectrum of visible light is divided into three primary colours and three secondary colours. The primary colours of light are red, green and blue (RGB).

The secondary colours are yellow, cyan and magenta. When used in the printing industry to create images black is added (CMYK or four-colour printing).

Each secondary colour is a combination of two primary colours and is '**complementary**' to the third primary.

- ~ Yellow is complementary to blue
- ~ Cyan is complementary to red
- ~ Magenta is complementary to green

# Filter categories

Filters can be divided into five main categories:

~   Neutral filters
~   Black and white
~   Colour conversion
~   Colour balancing
~   Effects

## Neutral filters

A range of filters are manufactured that have little or no colour.  These include:

~   UV (haze) and 'Skylight' filters (clear)
~   Neutral density filters (grey)
~   Polarising filters (grey)

*Skyline highway*

## UV and skylight filters

Ultra-violet (UV) radiation present in the spectrum of light is invisible to human vision but adds to the overall exposure of the film.  It is most noticeable with landscape images taken at high altitude and seascapes.  To ensure the problem is eliminated, UV filters can be attached to all lenses used on location.  If the optical quality of the filter is good the filters may be left permanently attached to the lenses.  The added benefit of this practice is the front lens element of each lens will be protected from scratching.

A Skylight filter also eliminates UV light and has a colour compensating effect.  Shadows filled by skylight have a blue cast and the slightly pink tinge of the filter helps to create shadows with a neutral colour cast when using colour transparency film.  Skylight filters are identified as a 1A and a stronger 1B.

# Neutral density filters

With manufacturers going to great lengths to create fast lenses with wide maximum apertures it may seem a little strange to find that a range of filters are available which reduce the light reaching the film at any given aperture.  These are the neutral density filters and are available in a range of densities.  If only one is purchased the photographer should consider one that can reduce the light reaching the film by at least two stops (four times).  Neutral density filters are used for two reasons:

~   Reducing depth of field
~   Increasing duration of exposure

## Reducing depth of field

Very shallow depth of field is not always possible when working on location if the ambient light is very bright.  If the photographer is using 100 ISO film and direct sunlight to illuminate the subject the photographer may only be able to select f5.6 or f8 as their maximum aperture, if the maximum shutter speed available on the camera being used is 1/1,000 or 1/500 second.  This aperture may not be enough to sufficiently isolate the subject.  If the aperture was increased further overexposure would result.  The problem can be solved by using a slower speed film, a modern camera with a focal plane shutter that is capable of exceeding 1/1000 second, or a neutral density filter.

*Duration of exposure - Sarah Irawatty*                    *Reducing depth of field*

## Increasing duration of exposure

Long exposures are not always possible when working on location if the ambient light is bright.  If the photographer is using 100 ISO film and direct sunlight to illuminate the subject the photographer may only be able to select 1/60 or 1/30 second as their slowest shutter speed, if the minimum aperture on the camera lens is f22 or f32.  This shutter speed may not be sufficient to give the movement blur required.  The problem can be solved by using a slower speed film, a lens with a minimum aperture smaller than f32 or a neutral density filter.

# Polarising filters

Polarised light is the light reflected off shiny non-metallic surfaces and parts of the blue sky. A polarising filter can reduce this polarised light and the effects are visible when viewing the image in the camera.

A polarising filter is one of the most useful filters a photographer can own. It is grey in appearance and when sold for camera lenses it consists of the actual filter mounted onto a second ring, thus allowing it to rotate when attached to the lens. The filter is simply turned until the desired effect is achieved.

The polarising filter is used for the following reasons:

~    Reduce or remove reflections from surfaces
~    Darken blue skies at a 90 degree angle to the sun
~    Increase colour saturation

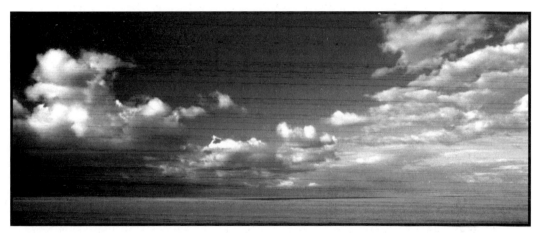

*Skyscape*

# Possible problems

The filter should be removed when the effect is not required. If not removed the photographer will lose two stops and reduce the ability to achieve overall focus.

When the polarising filter is used in conjunction with a wide-angle lens, any filter already in place should be removed. This will eliminate the problem of tunnel vision or clipped corners in the final image. Photographing landscapes when the sun is lower in the sky can result in an unnatural gradation, ranging from a deep blue sky on one side of the frame to a lighter blue sky on the other.

# Activity 1

Using 35mm transparency film take four images on a sunny day eliminating polarised light and the same four images without using the filter. At least one image should include water. Try to remove reflections from a shop window using a polarising filter.

How effective is the filter at eliminating these reflections?

Compare and contrast your results with other students.

# Black and white filters

When the photographer is using black and white film there is the option of controlling tonal values and contrast by using coloured filters, e.g. a green apple and an orange may record on black and white film with the same tonal value or shade of grey.  The use of an orange filter would result in the orange recording lighter and the apple darker, using a green filter would result in the apple recording lighter and the orange darker.  Filters lighten their own colour.  In this way the tones are made different.

Many photographers using black and white film use a yellow green filter as standard to correct the bias of the film towards the blue end of the spectrum.

The basic rule when using coloured filters with black and white film is:

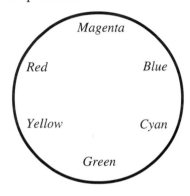

*The colour wheel*

**Adjacent colours are lightened**
**Opposite colours are darkened**

Using the colour wheel right, the photographer can quickly determine that colours the same as the filter and either side of the filter colour will be lightened. All others will be darkened.

| Black and white filters | | | |
|---|---|---|---|
| **Code** | **Colour** | **Filter factor** | **Effect** |
| Y2 | Yellow | 2 | Reduces exposure of blue sky. |
| G | Green | 4 | As for Y2 plus lightens green foliage and renders good skin tones for daylight portraits. |
| YG | Yellow/Green | 2 | Corrects tones to that of human vision. |
| O2 | Orange | 4 | Blue skies record as middle tones. |
| R2 | Red | 8 | Creates dark and dramatic skies. Underexposes green foliage. |

# Activity 2

Using black and white film produce a landscape image using one of the filters from the 'Black and white filter chart' above.

Take a control image without the use of a filter for comparison.

Print each image with the same grade filter or on the same grade paper.

# Colour coversion filters

The definition of a colour conversion filter is one that is used to convert the colour temperature of various light sources to match the colour balance of the film being used.

## Tungsten light

The most used filters for this purpose are the 80 series filters including the 80A and 80B. These filters are blue in colour and are used to balance daylight film with tungsten light sources. The 80B is used mainly in a studio situation to balance daylight film with photoflood bulbs specifically made for photographic lighting purposes.

|  | Daylight | 3400K | 3200K |
|---|---|---|---|
| Daylight film | None | 80B | 80A |
| Tungsten film | 85B | 81A | None |

*Colour conversion chart*

Nearly every professional location photographer will carry an 80A in their camera bag. This filter allows daylight film to be used with tungsten halogen lamps and record with approximately neutral tones. If daylight film is used in conjunction with an 80A filter and ordinary household light bulbs the resulting transparencies will still have a slightly warm cast.

A problem associated with using an 80A filter is the loss of two stops (filter factor 4). The photographer prepared for this will usually carry a 400 ISO film which they are prepared to push if necessary.

## Fluorescent light

It is very difficult to assess the colour cast that will result when fluorescent lights are illuminating the subject. Most images record with a green cast and most conversion filters are predominantly magenta coloured with additional yellow or cyan filtration. An FLD filter is marketed for use with fluorescent lights and daylight film but it usually only improves rather than rectifies the situation.

With six main types of fluorescent lights commercially available all requiring different colour conversions the best advice to a photographer is to:

**Switch fluorescent lights off if possible.**

Photographers leaving fluorescent lights on run the risk of a heavy colour cast. This is often an oversight or the photographer may think that the fluorescent lights are contributing little to the overall illumination and knowingly leave them on. The result is often devastating. Individuals with fair hair appear with bright green sprouting tufts from the tops of their heads and the tubes if in the frame appear as bright green.

# Colour balancing filters

Colour balancing filters are used to produce more subtle changes in the colour balance of the final image. They are particularly useful when working on location using colour transparency film. The most common light-balancing filters used are the 81 and 82 series filters. The 81 series are warm in colour (yellow) and the 82 series are cool in colour (blue). The subtlest changes are made with the straight 81 or 82 filter, the A, B and C becoming progressively stronger. Exposure compensation is between one third and two thirds of one stop.

| Warmer | | | | | Neutral | | Cool | Cooler |
|--------|--------|--------|--------|--------|--------|--------|--------|--------|
| 81EF | 81D | 81C | 81B | 81A 81 | * | 82 | 82A | 82B 82C |

One or two filters from the 81 series are particularly useful for removing the blue cast that is recorded when photographing in overcast conditions or in the shadows present on a sunny day. See the colour correction chart in **"Characteristics of Light"**.

# Effects filters

Numerous special effects filters are available from camera stores. Most are a little gimmicky and once used are quickly discarded by the serious professional. These include star-burst filters and graduated colour filters.

Probably the most commercially viable special effects filter is the soft focus filter or diffuser. This is especially useful in close-up portraiture where the photographer wants to create a flattering portrait but the sitter has a somewhat less than a perfect complexion.

# Effects with standard coloured filters

Many special effects can be created with conventional colour filters and a little imagination. These include using a coloured filter over a flash unit and a complementary filter on the camera lens. The effect is a neutral toned foreground with a background that bears the colour cast of the filter on the camera lens.

Another effect is obtained by mounting a camera on a tripod and taking three exposures of moving subjects on the same piece of film. If the photographer uses a different primary coloured filter (25 red, 61 green and 38A blue) for each of the exposures the effect is a near neutral background with coloured moving subjects. Take a meter reading without the filters attached and open up one stop for each of the three exposures.

# Activity 3

Using daylight colour transparency film take four images either in the shadows on a sunny day or on an overcast day and attempt to remove the blue cast using filtration.

Take a control image without filtration to compare and contrast your results.

# Filter factors

Filter factors are indications of the increased exposure necessary to compensate for the density of the filter. A filter factor of two indicates the exposure should be doubled (an increase of one stop). A filter factor of four indicates the exposure should be increased four fold (two stops) and eight requires three stops increased exposure.

## Establishing an appropriate exposure

When using a camera with TTL metering the light meter is reading the reduced level of transmitted light and so theoretically the exposure should require no compensation by the photographer. In practice, when using the deeper colour filters and TTL metering, it is advisable to take a meter reading before the filter is attached to the lens and then apply the filter factor. This leads to more accurate exposures being obtained as the meter can be misled by the coloured light if metering through the filter.

## Using more than one filter

Remove UV or skylight filters when using other filters. All filters provide UV filtration. Beware of vignetting or cropping the corners of the image when using multiple filter combinations.

When using two filters the combined filter factors should be multiplied not added. If a neutral density filter with a filter factor of four is used in conjunction with an orange filter, also with a filter factor of four, the resulting filter factor would be sixteen, not eight. Adding the filter factors instead of multiplying them would lead to a one stop underexposure.

## Filter factor table

| Filter factor | Exposure increase in stops | Density |
|:---:|:---:|:---:|
| 1.25 | 1/3 | 0.1 |
| 1.5 | 2/3 | 0.2 |
| 2 | 1 | 0.3 |
| 2.5 | 1 1/3 | 0.4 |
| 3 | 1 2/3 | 0.5 |
| 4 | 2 | 0.6 |
| 5 | 2 1/3 | 0.7 |
| 6 | 2 2/3 | 0.8 |
| 8 | 3 | 0.9 |
| 10 | 3 1/3 | 1.0 |

# Revision exercise

Q1.    What is the difference between a skylight filter and a UV filter?

Q2.    Describe a photographic situation that would necessitate the use of a neutral density filter.

Q3.    When using a wide-angle lens and a polarizing filter what precautions must the photographer take to ensure a successful image?

Q4.    What coloured filter is required to correct tones to that of human vision when using black and white film?

Q5.    How would you calculate the exposure compensation necessary when using a red filter and a 35mm SLR camera using TTL metering.

Q6.    What filter is required to convert the colour temperature of daylight to that which is suitable for a tungsten film?

Q7.    What is the difference between an 80A and an 80B filter?

Q8.    What is an FLD filter?

Q9.    Which is warmer in colour, an 81A or an 81EF filter?  With what lighting conditions would you use each filter?

# Resources

*Basic Photography - Michael Langford.*  Focal Press.  London.  1997.
*Encyclopedia of Photography.*  Crown Publishers.  New York.  1984.
*Essential Skills: Studio Photography - John Child.*  Focal Press.  London.  1999.
*Essential Skills: Location Photography - Mark Galer.*  Focal Press.  London.  1999.
*Focal Encyclopedia of Photography.*  Focal Press.  London.  1993.
*Light Science and Magic - Fil Hunter and Paul Fuqua.*  Focal Press.  Boston.  1997.
*Photography - Barbara London and John Upton.*  Harper Collins.  New York.  1994.
*The Professional Guide to Photo Data - Richard Platt.*  Mitchell Beazley.  London.  1991.

# Gallery

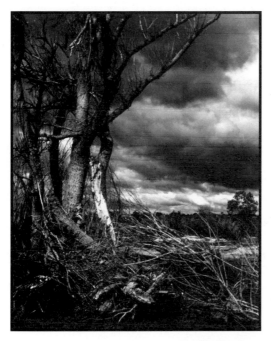

*Ann Ouchterlony*

*Mark Galer*

*Mark Galer*

# Gallery

*Mark Galer*

*Mark Galer*

# Characteristics of Light

*Mark Galer*

## Aims

~ To develop knowledge and understanding of how light can change the character and mood of subject matter.
~ To develop an awareness of overall subject contrast and how this translates to photographic film.
~ To develop skills in controlling introduced lighting to location and studio.

## Objectives

~ **Research** - Produce research in your Visual Diary that looks at a broad range of lighting techniques.
~ **Discussion** - Exchange ideas and opinions with other students on the work you are studying.
~ **Practical work** - Produce photographic positives through close observation and selection that demonstrate how lighting techniques control communication.

# Introduction

Light is the essence of photography. Without light there is no photography. Light is the photographer's medium. The word photography is derived from the ancient Greek words, 'photos' and 'graph', meaning 'light writing'. To be fluent with the language of light the photographer must be fully conversant with its qualities and behaviour. In mastering the medium the photographer learns to take control over the final image. To manage the medium takes knowledge, skill and craftsmanship. It can at first seem a complex and sometimes confusing subject. With increased awareness and practical experience however, the student finds light becomes an invaluable tool, rather than an obstacle, to communication.

## Seeing light

In order to manage a light source, we must first be aware of its presence. Often our preoccupation with content and framing can make us oblivious to the light falling on the subject and background. We naturally take light for granted. This can sometimes cause us to simply forget to 'see' the light. When light falls on a subject it creates a range of tones we can group into three main categories: **Highlights, Mid-tones** and **Shadows**.

Each of the categories can be described by their level of illumination (how bright, how dark) and their distribution within the frame. These are in turn dictated by the relative position of **Subject, Light source** and **Camera**.

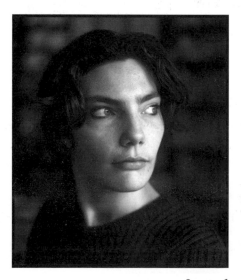 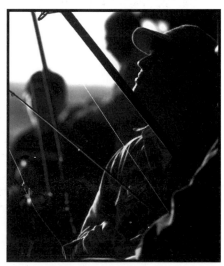

*Image 1*                                                        *Image 2*

# Activity 1

Describe the above images in terms of highlights, mid-tones and shadows.
Draw a diagram for each to indicate the relative position of subject, light source and camera.

# Introducing light

The major difference between studio and location photography is that the studio itself has no ambient or inherent light. The photographer starts with no light at all and has to previsualise how to light the subject matter and what affect the light will have upon the subject. Studio photographers have to previsualise the lighting of the subject rather than observe what already exists. This requires knowledge, craft, observation, organisation and discipline. Good studio photography takes time, lots of time, and **patience.**

*Joanne Gamvros*

*Sam Souter*

# Understanding the nature of light

In order to make the best use of an artificial light source, we must first be aware of how light acts and reacts in nature. Observation of direct sunlight, diffuse sunlight through cloud and all its many variations will develop an understanding of the two main artificial studio light sources available. A spotlight imitates the type of light we see from direct sunlight, a hard light with strong shadows and extreme contrast. A floodlight imitates the type of light we see on an overcast day, a soft diffuse light with minor variations in contrast and few shadows.

To understand light fully it is essential to examine its individual characteristics.

- ~ **Source**
- ~ **Intensity**
- ~ **Quality**
- ~ **Colour**
- ~ **Direction**
- ~ **Contrast**

# Source

## Ambient

Ambient light is existing natural or artificial light present in any environment.  Ambient light can be subdivided into four major categories:

~   **Daylight**
~   **Tungsten**
~   **Fluorescent**
~   **Firelight**

## Daylight

Daylight is a mixture of sunlight and skylight.  Sunlight is the dominant or main light.  It is warm in colour and creates highlights and shadows.  Skylight is the secondary light.  It is cool in colour and fills the entire scene with soft diffused light.  Without the action of skylight, shadows would be black and detail would not be visible.  Most colour films are calibrated to daylight at noon (5500K).  When images are recorded at this time of the day the colours and tones reproduce with neutral values i.e. neither warm nor cool.

## Tungsten

A common type of electric light such as household bulbs /globes and photographic lamps. A tungsten element heats up and emits light.  Tungsten light produces very warm tones when used as the primary light source with daylight film.  Underexposure occurs due to the lack of blue light in the spectrum emitted.  The orange colour cast can be corrected with a blue filter if neutral tones are desired.  Correct colour can be achieved without filtration if used with tungsten film

## Fluorescent

Phosphors inside fluorescent tubes radiate light after first absorbing ultraviolet light from mercury vapour emission.  The resulting light produces a strong green cast that is not apparent to the human vision.  If used as a primary light source the results are often unacceptable due to the broad flat light and the strong colour cast. Underexposure is again experienced when using this light source and the cast can be difficult to correct. Fluorescent light flickers and causes uneven exposure with focal plane shutters.  To avoid this shutter speeds slower than 1/30 second should be used.

## Firelight

Light from naked flames can be very low in intensity.  With very long exposures it can be used to create atmosphere and mood with its rich red tones.

# Artificial light

## Tungsten (non-domestic)

There are many variations of non-domestic tungsten light sources used in a photographic studio. They all fall in to the two major categories, floodlight and spotlight. The majority have a colour temperature of 3200K and are compatible with tungsten colour film and any black and white film. A simple flood light would have an output of 500 watts and a focusing spotlight suitable for the purposes of this study guide around 650 watts.

Professional spotlights come with barn doors and nets. Barn doors are metal flaps used to control the shape and quantity of light falling on the subject. Nets are pieces of wire gauze of varying densities that reduce the quantity and alter the quality of the light by diffusing the light at its source. Similar items used to create the same effect when using a floodlight are known as cutters (shape and quantity) and various diffusion material (quantity and quality). If possible all light stands should have wheels to ensure ease of movement and to reduce vibration when moving a light. See "**Studio Lighting**".

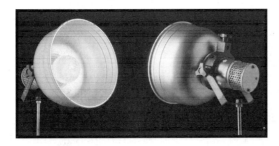

*Floodlight*

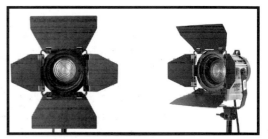

*Spotlight*

## Flash (studio)

The main differences between location and studio based flash are size, cost and output. Studio flash is physically larger, costs a great deal more and produces a far greater output of light. As with tungsten lighting there are numerous flash equivalents of the two standard light sources, flood and spot. The majority have a colour temperature of 5800K and are compatible with daylight and black and white film. Despite the names, swimming pool, soft box, fish fryer, etc. these are really only large or smaller versions of a diffuse light source. The use of an open flash (direct light to subject without diffusion) will give the same effect as a spotlight. Most brands have focusing capabilities and the range of attachments available for tungsten exist in one form or another for use with flash. See "**Studio Lighting**".

## Activity 2

Find examples that show the different use of studio based artificial light sources. Divide your examples into which you think are tungsten and which you think are flash. Explain your reasons and keep in your Visual Diary for future reference.

# Intensity

Light intensity is a description of the level of a light's brightness.  The intensity of light falling on a subject can be measured using a light meter.  An '**incident reading**' can be taken using a hand-held light meter.  A light meter built into a camera does not directly measure the intensity of light falling on the subject but the level of light reflected from it.  This is called a '**reflected reading**'.

*Merapi*

# Reflectance

Regardless of the intensity of the light falling on the subject different levels of light will be reflected from the subject.  The amount of light reflecting from a surface is called '**subject reflectance**'.  The levels of reflectance vary according to the colour, texture and angle of the light to the subject.  A white shirt will reflect more light than a black dress.  A sheet of rusty metal will reflect less light than a mirror.  In all cases the level of reflectance is directly proportional to the viewpoint of the camera.  If the viewpoint of the camera is equal to the angle of the light to the subject the reflectance level will be greater.  The level of reflected light is therefore determined by:

~ Reflectance of the subject.
~ Intensity of the light source.
~ Angle of viewpoint and light to subject.
~ Distance of the light source from the subject.

**Although the intensity of the light source may remain constant (such as on a sunny day) the level of reflected light may vary.**

# Fall-off

As the distance between the subject and the light source increases the level of light illuminating the subject decreases. The amount of light falling on a subject decreases to 25% of its original intensity when the light to subject distance is doubled. This change in the level of illumination is called fall-off and is quantified by the 'Inverse square law'.

For example, if a reading of f16 is obtained when the light to subject distance is one metre, at two metres the reading would be f8, at four metres f4. These rules do not change regardless of the light source.

Although fall-off does not present a problem when working with direct sunlight (all subjects being the same distance from the sun), it does need to be considered with reflected light, window light and artificial light sources. The visual effect of subjects at differing distances to the light source is uneven illumination.

## Inverse square law

**When a surface is illuminated by a point source of light the intensity of the light at the surface is inversely proportional to the square of its distance from the light source.**

*Light fall-off - David Williams*

# Activity 3

Using a floodlight, illuminate two people standing at one and two metres from the light source.

Take a light meter reading of either person.

Using colour transparency film make an exposure at this reading. Seek assistance if you are unsure of the equipment.

Move the floodlight two metres further away so that the people are now three and four metres from the light source.

Make a second exposure at the original meter reading.

Compare the results and record them in your Visual Diary.

# Quality

Light from a point light source such as a tungsten-halogen spotlight or the sun is described as having a 'hard quality'. The directional shadows created by this type of light are dark with well-defined edges. The shadows created by the sun are dark but not totally devoid of illumination. This illumination is provided by reflected skylight. The earth's atmosphere scatters some of the shorter blue wavelengths of light and provides an umbrella of low-level light. Electric point light sources create a much harsher light when used at night or away from the softening effects of skylight.

The light from a point source can be diffused, spread or reflected off larger surface areas. Directional light is scattered in different directions when reflected off a matte surface. The level and harshness of the light is also lowered. Shadows receiving very little light when compared to the highlights now receive proportionally more. The light is said to have a softer quality. The shadows are less dark (detail can be seen in them) and the edges are no longer clearly defined.

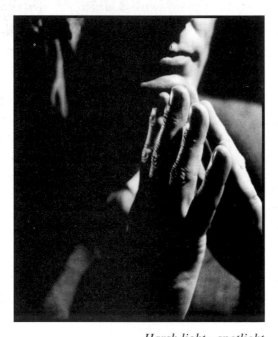

*Harsh light - spotlight*          *Soft light - window light - Lee Rosperich*

**The smaller the light source, the harder the light appears.**
**The larger the light source, the softer the light appears.**

The control over quality of light is an essential skill when on location. Often the photographer will encounter scenes where the quality of the ambient light provides enormous difficulties for the photographic materials being used. The photographer must learn techniques to alter the quality of light or risk loss of detail and information. The quality of light, whether hard or soft, can be changed by diffusion and reflection.

# Diffusion

A light source can be diffused by placing certain materials between the light source and the subject. This has the affect of diffusing and spreading the light over a greater area by artificially increasing the size of the source. Relevant to its size, the further the diffusion material from the light source the larger the light appears to be. This softens the shadows, increases shadow detail and decreases the measured amount of light falling on the subject.

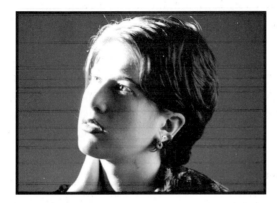

*Direct light*                                    *Diffused light*

# Reflection

Light is reflected off surfaces to varying degrees. More light will be reflected off silver than off black. Reflection is a simple way of changing the quality of light. The amount of light reflected off a surface is directly related to subject contrast. A point source of light will give hard shadows to the left side of a subject when lighted from the right. This is called high contrast as there are only highlights and shadows. A reflector used to reflect the light passing the subject back onto the left side would reduce the contrast by raising the detail in the shadows to a level closer to the highlights.

# Activity 4

Load a small format camera (35mm) with tungsten colour transparency film.
Photograph a subject with average tones (another person) under many varied light sources.
Include daylight, domestic lighting, street lighting, commercial and industrial lighting and light sources in your studio.
Keep a record of exposure and light source.
Process the film and collate the results with your written record.
Observe how the quality of the light varies from light source to light source and the differences in the reflective levels of elements in the photographs.
Compile this information in your Visual Diary.
Compare and discuss the results with other students and lecturers.

# Colour

The visible spectrum of light consists of a range of wavelengths from 400 nanometres (nm) to 700nm. Below 400nm is UV radiation and X-rays and above 700nm is infra red (all capable of being recorded on photographic film). When the visible spectrum is viewed simultaneously we see 'white light'. This broad spectrum of colours creating white light can be divided into the three primary colours: **blue, green and red.**

The precise mixture of primary colours in white light may vary from different sources . The light is described as cool when predominantly blue, and warm when predominantly red. Human vision adapts to different mixes of white light and will not pick up the fact that a light source may be cool or warm unless it is compared directly with another in the same location.

The light from tungsten bulbs and firelight consists predominantly of light towards the red end of the spectrum. The light from tungsten-halogen and photoflood lamps is also predominantly light towards the red end of the spectrum. The light from AC discharge and flash consists predominantly of light towards the blue end of the spectrum. Daylight is a mixture of cool skylight and warm sunlight. Daylight colour film is balanced to give fairly neutral tones with noon summer sunlight. When the direct sunlight is obscured or diffused however the skylight can dominate and the tones record with a blue cast. As the sun gets lower in the sky the light gets progressively warmer and the tones will record with a yellow or orange cast.

The colour of light is measured by colour temperature. Colour temperature is usually described in terms of degrees Kelvin (K). This simply refers to a temperature scale similar to Fahrenheit or Celsius.

**Tungsten film is rated at 3200K.  Daylight film is rated at 5500K.**

To control the colour of the final image the photographer has the option to either choose the time of day to create images or use photographic filters to reduce or remove the colour cast. Filtration can be used to balance any film to any lighting situation. The filtration required to correct most common light sources is listed in the manufacturer's specifications packaged with the film. More comprehensive lists are available from the film or filter manufacturer.

# Activity 5

Using either daylight or tungsten transparency film photograph subjects under various light sources and lighting conditions.

In each situation expose one frame without filtration and one frame with the appropriate filter from the list opposite.

Experiment with incorrect filtration.

Record all details and collate with the processed film in your Visual Diary.

Observe how sometimes an inappropriate filter can create an interesting effect.

# Colour correction chart

| Light source | Colour temperature | Film | Filter | Exposure |
|---|---|---|---|---|
| Average shade | 8000K | Daylight | 81EF | +0.65 |
| | | Tungsten | 85B | +0.65 |
| Overcast sky | 7000K | Daylight | 81D | +0.65 |
| | | Tungsten | 85B | +0.65 |
| Lightly overcast sky | 6000K | Daylight | 81A | +0.35 |
| | | Tungsten | 85B | +0.65 |
| Flash | 5800K | Daylight | None | |
| | | Tungsten | 85B | +0.65 |
| AC Discharge | 5600K | Daylight | None | |
| | | Tungsten | 85B | +0.65 |
| Daylight | 5500K | Daylight | None | |
| | | Tungsten | 85B | +0.65 |
| Early morning late afternoon | 3500K | Daylight | 82C | +0.65 |
| | | Tungsten | 81B | +0.35 |
| Photoflood | 3400K | Daylight | 80B | +1.65 |
| | | Tungsten | None | |
| Tungsten-halogen | 3200K | Daylight | 80A | +2.00 |
| | | Tungsten | None | |
| Domestic globes | 2800K | Daylight | 80A | +2.00 |
| | | Tungsten | 82C | +0.65 |
| Sunset | 2000K | Daylight | 80A | +2.00 |
| | | Tungsten | 82C+82C | +1.35 |
| Candle flame | 1850K | Daylight | 80A | +2.00 |
| | | Tungsten | 82C+82C | +1.35 |
| Match flame | 1700K | Daylight | 80A | +2.00 |
| | | Tungsten | 82C+82C | +1.35 |

# Direction

## In the studio

The direction of light determines where shadows fall and their source can be described by their relative position to the subject.  Shadows create texture, shape, form and perspective. Without shadows photographs can appear flat and visually dull.  A subject lit from one side or behind will not only separate the subject from its background but also give it dimension. A front lighted subject may disappear into the background and lack form or texture.  In nature the most interesting and dramatic lighting occurs early and late in the day. Observing and adapting this approach is a starting point when undertaking studio lighting.

*Tejal Shah*                                    *Dianna Snape*

## On location

Many location photographs looking flat and uninteresting.  Photographers arriving at a location when the sun is high find a flat even illumination to the environment.  The colours can look washed out and there is little or no light and shade to create modelling and texture. The mood and atmosphere of a location can be greatly enhanced by the simple realisation that most successful location images are taken when the sun is low, or as it breaks through cloud cover to give uneven and directional illumination.  When the sun is high or diffused by cloud cover the mood and the subject contrast usually remains constant.  When the sun is low the photographer can often choose a variety of moods by controlling the quantity, quality and position of shadows within the image.

# Early and late light

Many photographers consider dawn and dusk prime times to be photographing.  The colours are often rich and intense and the opportunities to shoot into the light and find broken light increase dramatically.  Dawn in summer is especially useful as landscapes are often very still and the morning mist can increase the mood and atmosphere dramatically.

*Bath*

# Activity 6

Using daylight colour transparency film visit the same location at dawn, midday and sunset. Photograph the effect of the light on the same subject from the same viewpoint each time. Be sure to take images of the effect of the light on the location not just the light source itself. Compare the colour and quality of light in the images and comment on the mood that is communicated.

Using tungsten colour transparency, or daylight colour transparency with appropriate filtration, attempt to reproduce in the studio the different lighting effects that appear on your transparencies.  Use a simple object trying various combinations of studio lights.

Compare the quality of the light and comment on the effectiveness to reproduce the lighting captured on location.

# Contrast

Contrast is the degree of difference between the lightest and darkest tones of the subject or photographic image. A high-contrast photograph is one where dark tones and bright tones dominate over the mid-tones within the image. The highest contrast image possible is one that contains only two tones, black and white and where no mid-tones remain. A low contrast image is one where mid-tones dominate the image and there are few if any tones approaching white or black.

Without contrast photographic images would appear dull and flat. It is contrast within the image that gives dimension, shape and form. Awareness and the ability to understand and control contrast is an essential skill to work successfully in the varied and complex lighting situations that arise on location and in the studio.

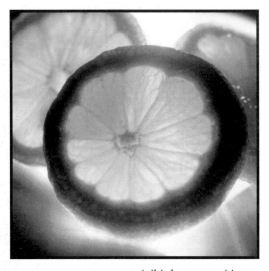

*A 'high contrast' image*                    *A 'low contrast' image*

## Affecting contrast

Contrast is affected by the difference in the intensity of the light falling on a subject and the intensity this light reflects back to the viewer or film.

Light usually strikes three-dimensional subjects unevenly. Surfaces facing the light may receive full illumination, whilst surfaces turned away from the light receive little or none. Different surfaces reflect different amounts of light. A white shirt reflects more light than black jeans. The greater the difference in the amount of light reflected, the greater the subject contrast.

When harsh directional light strikes a subject the overall contrast of the scene increases. The highlight tones facing the light source continue to reflect a high percentage of the increased level of illumination whilst the dark tones in the shadows may reflect little. The difference between the darkest and the lightest tone increases, leading to increased contrast.

# Limitations of the medium

The human eye can register detail in a wide range of tones simultaneously. Film is unable to do this. It can record only a small range of what human vision is capable of seeing. The photographer has the option of recording a selected range of tones or seek ways of lowering the contrast.

In an attempt to visualise how the contrast of a subject will be translated by the photographic medium many photographers use the technique of squinting or narrowing the eyes to view the scene. This technique removes detail from shadows and makes the highlights stand out. In this way it is possible to predict the contrast of the resulting image.

# Contrast on location

Cloud cover diffuses and softens the light leading to lower contrast. Shadows appear less harsh and with softer edges. The lighting may be described as being flat and the film will usually be able to record the range of tones present if accurately exposed.

When direct sunlight strikes the subject the contrast usually exceeds the film's capability to record the range of tones. The photographer may have to seek a compromise exposure.

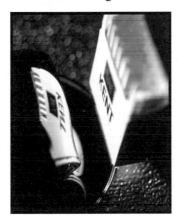
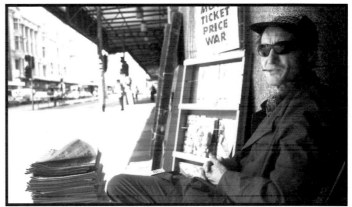

*Joshua Poole*                                   *Flinders Street Station*

# Creating contrast

Working in a studio situation where the subject and lighting are under the control of the photographer contrast is usually by design rather than by any error of judgement. As all the elements that cause contrast are controlled by the photographer it can be created and used to great effect. Placing highlights in shadow areas and deep shadows through mid-tones can create interesting images.

# **Activity 7**

Find six images (from commercial and amateur sources) where the contrast of the subject has exceeded the ability of the film to record the range of tones present.

Discuss the effectiveness of the lighting in each of the six images.

# Revision exercise

Q1.    Light falling on a subject can be divided into three categories.  What are they?

Q2.    Ambient light can be divided into four sources.  Which of the four has the highest colour temperature?

Q3.    Is the colour temperature of studio flash greater or lower than average shade?

Q4.    Studio lights can be divided into continuous and non-continuous sources.  Which lights fall into which category?

Q5.    The reflectance of light is determined by four factors.  What are they?

Q6.    Using common usage describe what is meant by the inverse square law.

Q7.    What colour cast, if any, would daylight film have if correctly exposed without filtration on an overcast day?

Q8.    Contrast is determined by a combination of two factors.  What are they?

Q9.    What correction filter would be used when using tungsten film on exterior location in early morning light?

Q10.   Tungsten domestic lighting falls at which end of the visible spectrum?

# Resources

*American Cinematographer Manual.*  ASC Press.  Hollywood.  1993.
*Arriflex Professional Products.*  Arriflex Corporation.  New York.  1998.
*Basic Photography - Michael Langford.*  Focal Press.  London.  1997.
*Essential Skills: Studio Photography - John Child.*  Focal Press.  London.  1999.
*Essential Skills: Location Photography - Mark Galer.*  Focal Press.  London.  1999.
*Kodak Professional Products.*  Kodak (Australasia) Pty. Ltd. Melbourne.  1998.
*Light Science and Magic - Fil Hunter and Paul Fuqua.*  Focal Press.  Boston.  1997.
*Photographing in the Studio - Gary Kolb.*  Brown & Benchmark.  Wisconsin.  1993.
*Photography - Barbara London & John Upton.*  Harper Collins.  New York.  1994.

# Gallery

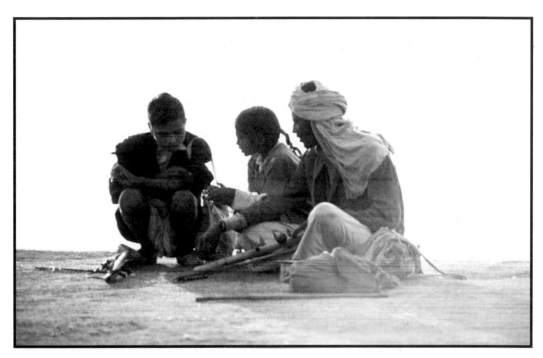

*Mark Galer*

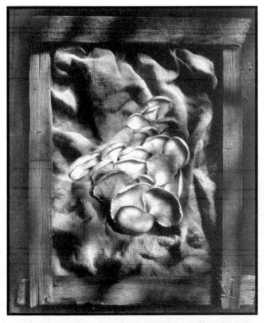

*Wil Gleeson*

*Gary Gross*

# Gallery

*Coralie Ryan*

*Joanne Gamvros*                                              *Kathryn Marshall*

# Contrast and Compensation

*Chloe Paul*

## Aims

~ To develop knowledge and understanding of contrast and exposure compensation and its relationship to the correct exposure of film.
~ To develop an understanding of the relationship between lighting contrast, lighting ratios, subject contrast and subject brightness range and their effect upon the photographic image.

## Objectives

~ **Research** - Produce research in your Visual Diary that shows an understanding of the affect of contrast and exposure compensation.
~ **Discussion** - Exchange ideas and opinions with other students and lecturers on the work you are studying.
~ **Practical work** - Produce colour transparencies through close observation and selection that show an understanding of contrast and exposure compensation.

# Contrast

The human eye simultaneously registers a wide range of light intensity. Due to its limited latitude film in unable to do this. The difference in the level of light falling on or being reflected by a subject is called contrast. Without contrast photographic images can appear dull and flat. It is contrast within the image that gives dimension, shape and form. Awareness and the ability to understand and control contrast is essential to work successfully in the varied and complex situations arising in photography. Contrast can be subdivided into three areas:

~ **Subject contrast**
~ **Lighting contrast**
~ **Brightness range**

## Subject contrast

Different surfaces reflect different amounts of light. A white shirt reflects more light than black jeans. The greater the difference in the amount of light reflected the greater the subject contrast or '**reflectance range**'. The reflectance range can only be measured when the subject is evenly lighted. The difference between the lightest and darkest tones can be measured in stops. If the difference between the white shirt and the black jeans is three stops then eight times more light is being reflected by the shirt than by the jeans (a reflectance range of 8:1).

**One stop = 2:1, two stops = 4:1, three stops = 8:1, four stops = 16:1,**

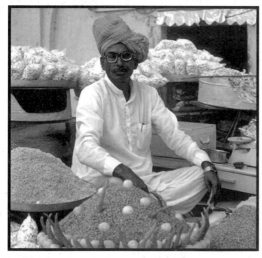 

A '**high contrast**' image is where the ratio between the lightest and darkest elements exceeds 32:1

A '**low contrast**' image is where the ratio between the lightest and darkest elements is less than 2:1.

# Lighting contrast

When harsh directional light strikes a subject the overall contrast increases. The highlights continue to reflect high percentages of the increased level of illumination whilst the shadows reflect little extra.

> **Overall image contrast therefore is determined by the combined effects of subject contrast or reflectance range and the 'lighting contrast'.**

Lighting contrast describes the difference in the level of illumination between the main directional light (key light) and any light falling on the shadows (fill-light). The difference can be measured in stops and recorded as a '**lighting ratio**'. If the difference between the light illuminating the highlights and the light illuminating the shadows is two stops, the lighting ratio is given as 4:1, i.e. four times more light strikes the tones facing the light as the same tones in the shade. This is easily measured by taking an incident light meter reading in the light and then in the shadows.

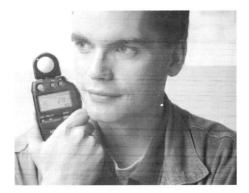

*Metering to establish a lighting ratio. Tim Roberts, RMIT*

**On location** - when there is cloud covering the sun the light is diffused or softened. The difference between a tone placed in the diffused light and open shade (away from structures and large objects) may be less than one stop, giving a lighting ratio of less than 2:1. The lighting may be described as being flat and the lighting contrast as low.

When direct sunlight strikes the subject the difference between a tone placed in the sun and the same tone placed in covered shade may increase beyond two stops or 4:1. This directional light creating highlights and shadows is described as high contrast.

**In the studio** - lighting contrast is controlled by the photographer. The direction, intensity, degree of diffusion and amount of fill-light will all be deciding factors in creating a lighting ratio suitable for the desired lighting contrast range.

| Stops difference | Light ratio | Stops difference | Light ratio |
|:---:|:---:|:---:|:---:|
| 2/3 | 1.6:1 | 2 | 4:1 |
| 1 | 2:1 | 2 1/3 | 5:1 |
| 1/1/3 | 2.5:1 | 2 2/3 | 6:1 |
| 1 2/3 | 3:1 | 3 | 8:1 |

# Brightness range

Subject luminance range is the combined effects of subject and lighting contrast. Because the acronym 'SLR' is more usually associated with the term single-lens reflex, subject luminance range is often referred to as subject brightness range.

If a subject with a reflectance range of 32:1 (high subject contrast) is placed in harsh directional sunlight with a lighting ratio of 4:1 the overall contrast or 'subject brightness range' (SBR) of this scene can be recorded as 128:1.

**Subject brightness range (SBR) = Reflectance range x lighting ratio.**

Film is capable of recording a limited tonal or brightness range. A subject photographed in high contrast lighting may exceed this recordable range. The ability for the film to accommodate a brightness range is referred to as its '**latitude**'.

Colour transparency film and colour prints have the ability to accommodate a brightness range of only 32:1 or five stops. Black and white prints will accommodate a brightness range of 128:1 or seven stops. With this knowledge the photographer working in colour will understand that any highlight or shadow more than two stops brighter or darker than the mid-tone will not register with any detail. When working in black and white the photographer has the increased flexibility to extend this range three stops either side of the mid-tone and still register detail. Specialist processing and printing techniques can extend this range still further.

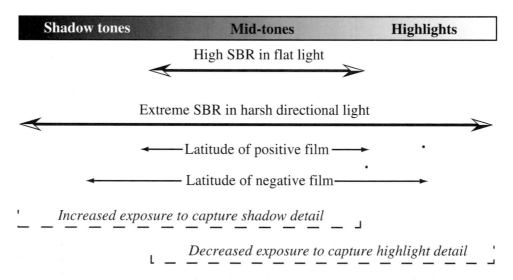

*A subject with a high or extreme brightness range can exceed the latitude of the film*

Awareness of the subject brightness range and the capability of the photographic medium allows the photographer to previsualise or predict the outcome of the final image. When the brightness range exceeds the films capabilities the photographer has the option to lower the lighting contrast or adjust the exposure to protect shadow or highlight detail that would otherwise not record. This is called '**exposure compensation**'.

# Exposure compensation

When working on location the lighting (sunlight) already exists. There is often little the photographer can do to lower the brightness range. In these instances exposure compensation is often necessary to protect either shadow or highlight detail. The results of exposure compensation are most easily assessed using transparency film. The amount of compensation necessary will vary depending on the level of contrast present and what the photographer is trying to achieve. Compensation is usually made in 1/3 or 1/2 stop increments but when a subject is back-lit and TTL metering is used the exposure may need increasing by two or more stops depending on the lighting contrast. Remember that:

**Increasing exposure will reveal more detail in the shadows and dark tones**
**Decreasing exposure will reveal more detail in the highlights and bright tones.**

## Exposure compensation dial

The use of a compensation dial is required when the photographer wishes to continue working with an automatic metering system instead of using the manual controls. Using an automatic metering mode the photographer cannot simply adjust the exposure, from that indicated by the meter, using the aperture or shutter speed. The automatic mode will simply re-compensate for the adjustment.

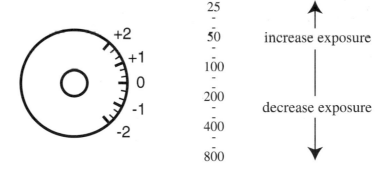

## Compensating by altering film speed

If the camera is not equipped with an exposure compensation dial compensation may be achieved by altering the film speed. By decreasing the film speed from 100 ISO to 50 ISO the photographer will increase the exposure by one stop. By doubling the film speed the exposure will be decreased by one stop. Films are available in 1/3 stop increments so this allows compensation in 1/3 increments. The disadvantage to using the film speed dial is that it is usually not as conveniently situated on the camera, may require an additional button to be depressed before it can be altered, and there is usually no indication that compensation is being used in the viewfinder. Without this reminder the photographer must return the film speed to the correct setting after each shot or run the risk of compensating all subsequent shots.

# Assessing the degree of compensation

Photographers can calculate the degree of compensation from MIE in a variety of different ways. The method chosen is often dictated by whether speed or accuracy is required.

**Bracketing** - The photographer can estimate the necessary compensation by bracketing the exposures. To bracket the exposure the photographer must expose several frames, varying the exposure in 1/3 or 1/2 stop increments either side of the MIE.

**18% Grey card** - Photographers can use a mid-tone of known value from which to take a reflected light meter reading. A mid-tone of 18% reflectance is known as a 'grey card'. The grey card must be at the same distance from the light source as the subject. Care must be taken to ensure that the shadow of neither the photographer nor the light meter is cast on the grey card when taking the reading. When using colour transparency or positive film the indicated exposure is suitable for a SBR not exceeding 32:1. If highlight or shadow detail is required the exposure must be adjusted accordingly. When using black and white or colour negative film the indicated exposure is suitable for a SBR not exceeding 128:1. If the SBR exceeds 128:1 the exposure can be increased and the subsequent development time decreased. See **"The Zone System"**.

**Polaroid** - Working in a studio, and on location with some medium format cameras, a photographer has the added advantage of being able to use Polaroid to assess exposure and composition. Most film has a Polaroid of equal ISO and comparative contrast range. To best understand the relationship between Polaroid and film testing of both is recommended. This will give you the best correlation between how the correct exposure for film would appear on an equivalent Polaroid. Polaroid film holders (backs) fit most medium and all large format cameras. Polaroid backs suitable for small format cameras are very limited.

**Caucasian skin** - A commonly used mid-tone is Caucasian skin. A reflected reading of Caucasian skin placed in the main light source (key light) is approximately one stop lighter than a mid-tone of 18% reflectance. Using this knowledge a photographer can take a reflected reading from their hand and increase the exposure by one stop to give an exposure equivalent to a reflected reading from an 18% grey card. Adjustments would be necessary for an SBR exceeding the latitude of the film.

**Re-framing** - If the photographer is working quickly to record an unfolding event or activity the photographer may have little or no time to bracket or take an average mid-tone reading. In these circumstances the photographer may take a reading quickly from a scene of average reflectance close to the intended subject. This technique of re-framing may also include moving closer to the primary subject matter in order to remove the light source and the dominant light or dark tones from the framed area. Many modern cameras feature an exposure lock to enable the photographer to find a suitable exposure from the environment and lock off the metering system from new information as the camera is repositioned.

**Judgement** - The fastest technique for exposure compensation is that of judgement, gained from experience and knowledge. This requires the photographer to previsualise the final image and estimate the degree of compensation required to produce the desired effect.

# Compensation for back-lighting

The most common instance requiring exposure compensation is 'back-lighting' using a TTL meter. The metering system will be overly influenced by the light source and indicate a reduced exposure. As the light source occupies more and more of the central portion of the viewfinder so the indicated exposure is further reduced. The required exposure for the subject may be many times greater than the indicated exposure.

*The Rhondda*

If the camera is in manual mode or equipped with an exposure lock, the photographer can meter for the specific tonal range required and then re-frame the shot. An alternative used by many professionals is to adjust the exposure using the exposure compensation dial. Using this technique can avoid re-framing after first metering.

# Activity 1

Load a 35mm SLR camera with medium-speed transparency film.
Choose four different lighting situations where the subject is back-lit.
Take a photograph of each subject with the 'meter indicated exposure' or MIE.
**Do not reposition the frame.** Make a record of the exposures.
Using your own judgement compensate the exposure using either the exposure compensation dial or film speed dial. Make a record of the exposures.
Take a meter reading for the shadow area and with the camera set to manual take one shot at this reading. Make a record of the exposure.
Take a meter reading for the highlight area and with the camera set to manual take one shot at this reading. Make a record of the exposure.
Process the roll of film and label the results of each frame.

# Summary of exposure compensation

### Hand-held light meters

A hand-held reflected light meter reading measures the level of light reflected from the subject. The resulting exposure is an average between the light and dark tones present. When light and dark tones are of equal distribution this average reading is suitable for exposure. When light or dark tones dominate the photographer must either take a reflected meter reading of a known mid-tone and compensate accordingly, or take an incident reading of the light falling on the subject.

### TTL meters

The 'through-the-lens' (TTL) light meter measures the level of reflected light from the subject. The TTL meter does not measure the level of illumination (ambient light). The resulting exposure is an average between the light and dark tones present. When light and dark tones are of equal distribution within the frame this average light reading is suitable for exposing the subject. When light or dark tones dominate the photographer must either meter a known mid-tone or compensate the exposure accordingly.

---

## Summary of exposure compensation

| Dominant light tones | increase exposure | + | Open up |
| Dominant dark tones | decrease exposure | − | Stop down |

### Extreme contrast
Colour transparency

| Increase highlight detail | decrease exposure | − | Stop down |
| Increase shadow detail | increase exposure | + | Open up |

**Black and white negative**
SBR exceeding 128:1        increase exposure/reduce development time

---

# Activity 2

Place a small subject of dominant mid-tones one metre from a bright white background. Light with a diffuse light source (floodlight) and take a reflected light reading from the camera position.
Next take a reflected light reading of the subject only.
Test your judgement by determining correct exposure and exposing one frame only.

# Revision exercise

Q1. What is the lighting ratio of a subject measuring f16 in the highlights and f5.6 in the shadows?

Q2. If the reflectance range of the subject is four stops or 16:1 and the lighting ratio is 4:1 what would be the overall subject brightness range (SBR)?

Q3. After establishing the SBR for the above subject what action would you take to protect highlight detail using transparency film?

Q4. With a subject brightness range of 256:1 or eight stops what action would you take in exposing and processing a black and white film?

Q5. A photographer uses Caucasian skin to establish an exposure reading for a mid-tone. What adjustment should be made to the MIE to correctly expose for the mid-tone?

Q6. Explain the differences between lighting contrast and lighting ratio.

Q7. The studio photographer has many advantages over the location photographer when it comes to lighting contrast. What are they?

Q8. Altering a film's speed from 400 ISO to 100 ISO has what effect upon exposure?

Q9. A heavily back lighted subject can present a photographer with many problems. What are they?

Q10. When confronted with a lighting contrast ratio of 128:1, would a photographer choose colour transparency or colour negative film to achieve the best result?

# Resources

*Advanced Photography - Michael Langford.* Focal Press. London. 1997.
*American Cinematographer Manual.* ASC Press. Hollywood. 1993.
*Basic Photography - Michael Langford.* Focal Press. London. 1997.
*Black and White Photography - Rand/Litschel.* West Publishing Co. Minneapolis. 1994.
*Encyclopedia of Photography.* Crown Publishers. New York. 1984.
*Essential Skills: Studio Photography - John Child.* Focal Press. London. 1999.
*Essential Skills: Location Photography - Mark Galer.* Focal Press. London. 1999.
*Kodak Professional Products.* Kodak (Australasia) Pty. Ltd. Melbourne. 1998.
*Light Science and Magic - Fil Hunter and Paul Fuqua.* Focal Press. Boston. 1997.
*Photographing in the Studio - Gary Kolb.* Brown and Benchmark. Wisconsin. 1993.
*Photography - Barbara London and John Upton.* Harper Collins. New York. 1994.
*The Focal Encyclopedia of Photography.* Focal Press. London. 1993.

# Gallery

*RMIT*

*Elinor McRae*                                        *Gemma Gray*

# The Zone System

*Mark Galer*

## Aims

~ To increase knowledge and understanding concerning subject brightness range.
~ To increase control over the resulting tonal range of a black and white image.
~ To increase ability to previsualise the final printed image when viewing a scene.

## Objectives

~ **Research** - Photographic images created utilising the zone system.
~ **Discussion** - Exchange information and understanding with other students.
~ **Practical work** - Test the exposure index of the film you are using.
  Test the accuracy of the development you are using.
  Create images exposing for the shadows and processing for the highlights.

# Contrast control

The individual tones within the subject can be moved closer together (lowering the contrast) by reducing the processing time, or moved further apart (increasing the contrast) by increasing the processing time. Decreasing the processing time decreases the density of the highlights on the negative whilst leaving the shadow tones relatively unaffected. Increasing the processing time increases the density of the highlight tones on the negative whilst leaving the shadow tones relatively unaffected. There is some effect on the mid-tones in both instances but proportionally less than the highlights.

If shadows are missing from the negative (areas of clear film base within the frame) then no amount of extra development will reveal detail in these areas.

*Negative with good detail*          *Contrast exceeding the latitude of the film*

## Subject brightness range

The photographer can measure the contrast of the subject (subject brightness range) and then alter the processing of the negatives according to the desired contrast. The photographer exercises precise control by measuring the distance in stops between a highlight tone and shadow tone. If the distance between the selected highlight and shadow tones is greater than four stops (extreme contrast) processing can be decreased to lower the contrast of the image. If the distance between the selected highlight and shadow tones is less than four stops the processing can be increased to increase the contrast of the image.

## Summary so far

- The zone system is made up of ten major tones from black to white.
- Each tone is one stop darker or lighter than the next.
- Specific highlight and shadow tones of the subject are assigned to specific zones.
- Zone placement of a shadow tone is a subjective decision. The decision dictates what detail is visible and how dark these shadows appear in the final image.
- Development affects highlight tones proportionally more than shadow tones.
- Increased or decreased processing time leads to increased or decreased contrast.
- Subject contrast is measured in stops.
- Shadow tones are controlled by exposure and highlight tones by development.

# The zones

Each zone in the final image can be identified by its tone and the detail it reveals.
To obtain accuracy we must become familiar with the characteristics of each zone.

Zone XI. Paper white. The standard print utilising a full tonal range uses little or no paper white in the image.

Zone VIII. White without detail. The brightest highlights in the image are usually printed to this zone.

Zone VII. Bright highlights with visible detail or texture. If highlight detail is required it is placed in this zone by calculated processing time.

Zone VI. Light grey. Caucasian skin facing the light source is usually printed as Zone VI.

Zone V. Mid-grey with 18% reflectance. A meter indicated exposure from a single tone will produce this tone as a Zone V on the negative.

Zone IV. Dark grey.
Shadows on Caucasian skin are usually printed as Zone IV.

Zone III. Dark shadow with full detail and texture. If shadow detail is required it is placed in this zone by calculated exposure.

Zone II.
Shadow without detail.

Zone I.
Black.

Zone O.
Maximum black and is indistinguishable from Zone I in the printed image.

# Activity 2

Refer back to the three prints created for Activity 1.
Select the image with the broadest range of tones (best exposure).
Label this image with the zones from I to IX. Use the description of each zone on this page to help you identify each zone.
Compare and discuss your labelled image with those of other students.

# Zone recognition

Using the description in the previous section we are now able to recognise what each zone looks like in the printed image. Zones III and VII are of particular interest as they will indicate the accuracy of how a photographer has utilised the zone system. Important areas of shadow and highlight detail will have been preserved whilst still utilising zones II and VIII to give the print both depth and volume.

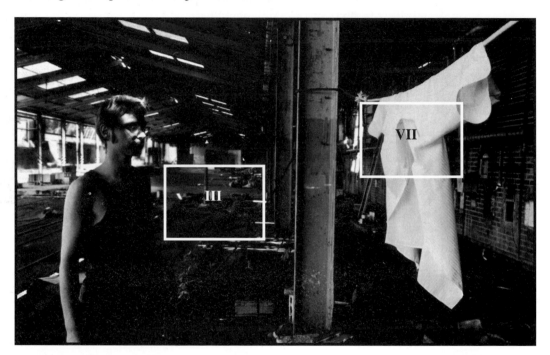

*Alan Fredes*

**Zone III**

**Zone VII**

*Dark shadow with full detail and texture. If shadow detail is required it is placed in this zone by calculated exposure.*

*Bright highlights with visible detail or texture. If highlight detail is required it is placed in this zone by calculated processing time.*

# Operating the system

Gaining maximum control over the system requires practice.  The student should take notes and compare the results with the actions taken.  Mistakes may be made initially but these mistakes will lead to a greater understanding of the system.

Testing the accuracy of exposure and negative processing is crucial to obtaining precise control over the zone system.  The photographer is advised to limit the combined choice of camera, light meter, film, developer, enlarger and printing paper until this control has been achieved, otherwise variations in outcome are inevitable.

*Jana Liebenstein*

## Choice of camera, light meter and film

Use a camera and a light meter that provide accurate exposures.  If the camera or meter receives a shock through impact, the equipment should be checked.  Some retail outlets will offer to test the accuracy of the equipment.

Select only one type of 100 ISO film until control has been achieved.  The student should ideally have some experience of processing this film prior to using it for the zone system.  Establish an '**exposure index**' for the film (see activity below).  The usable speed for the film may vary from the manufacturers recommended speed due to variety of reasons.

# Activity 3

Using black and white negative film, take several exposures of a subject with a four stop range.  Someone wearing a white shirt with dark trousers or jacket would be ideal.  Calibrate the exposure using a reflected light meter reading taken from a grey card.  The subject should be illuminated with diffused light  (cloud cover or shade).

Bracket the exposures (1/3 stop intervals) keeping a precise record of each frame.

Process the negatives according to the manufacturer's specifications.

View the negatives on a light box and choose the best exposure with the assistance of an experienced practitioner.  The darkest tones of the subject should render full texture and detail (no area of the image should appear clear).

Choose the best exposure and check your records to find the degree of compensation required.  For example if the best exposures for accurately rendering shadow detail is 2/3 stop more than the manufacturer's recommendation of 100 ISO then proceed to rate the film at 2/3 stop less, i.e. 64 ISO.

# Exposure and processing

The zone system can be approached in a series of sequential steps.  The entire system can be divided into two main practical skills.  These are:

~   **Exposing for the shadows.**
~   **Processing for the highlights.**

## Exposing for the shadows

View the subject and choose the dark shadows that you want to be able to see full detail and texture in  when you view the final image.  Take a specific reflected light meter reading from one of these dark shadow tones.  Use a hand-held meter at close range or fill the frame of a 35mm SLR with the selected tone.  Use a spot meter to isolate a tone from a distance.

Place the shadow tone in Zone III by stopping down two stops from your meter indicated exposure or MIE (e.g. if the light meter reading of the shadow tone is f4 @ 1/125 second then the final exposure could be f8 @ 1/125 second).  This action is called 'exposing for the shadows'.

*Note:  The original meter reading is often taken in the form of an 'EV' (exposure value) reading so that the final exposure can be interpreted by different combinations of aperture and shutter speed.*

*Metering for the shadows and processing for the highlights*

## Processing for the highlights

View the subject and choose the bright highlights that you want to be able to see full detail and texture in when you view the final image.  Take a specific reflected light meter reading from one of these bright highlights.  Measure how many stops brighter the highlights are than the shadows metered for in the previous step.  If the shadow tone meter reading was f4 @ 1/125 the highlight tone may measure f16 @ 1/125 (four stops difference).

For bright highlights to record as bright highlights with full detail and texture they must fall in zone VII (four stops brighter than the shadows).  If this is the case the negatives can be processed normally.  If the highlights measure more or less than four stops, decrease or increase processing time accordingly (see **"compression" and "expansion").**

# Adjusting the development time

It is recommended that '**one shot**' development (tank development using freshly prepared developer which is discarded after the film is processed) is used in conjunction with a standard developer. Developers such as **D-76** and **ID-11** are ideal for this test.

The student should use the same thermometer of known accuracy (check it periodically with several others) and adhere to the recommended development times, temperatures and agitation. A pre-wash is recommended to maintain consistency.

**Viewing the negatives** - The highlights of a high contrast subject should be dark but not dense when the negatives are viewed on a light box. Newspaper print slid underneath the negatives should easily be read through the darkest tones of the image. Manufacturers numbers and identifying marks on pre-loaded film should appear dark but not swollen or 'woolly'. The student should view the negatives in the presence of an experienced practitioner to obtain feedback.

# Compression

If the selected highlights measure five or six stops brighter than the shadows placed in Zone III they will fall in Zone VIII or IX respectively. No detail will be visible by processing and printing the negative normally. The highlight tones selected can be moved one or two zones down the scale to zone VII by decreasing the processing time. This situation is often experienced with a high to extreme subject brightness range (SBR).

Moving the highlights one zone down the scale is referred to as **N-1**, moving the highlights two zones down the scale is referred to as **N-2**. N-1 negatives are processed for approximately 85% of the normal processing time, N-2 negatives for approximately 75% of the normal processing time when using 100 ISO film. The action of moving highlight tones down the zone scale is called '**compaction**' or '**compression**'. Shadow tones remain largely unaffected by reduced processing time so the final effect is to lower the contrast of the final negative.

# Expansion

If the selected highlights measure only two or three stops brighter than the shadows they will fall in Zone V or VI respectively. Highlights will appear dull or grey if the negatives are processed and printed normally. The highlight tones selected can be moved one or two zones up the scale to Zone VII by increasing the processing time. This situation is often experienced with a low SBR or flat light.

Moving the highlights one zone up the scale is referred to as **N+1**, moving the highlights two zones up the scale is referred to as **N+2**. N+1 negatives are processed for approximately 130% of the normal processing time, N+2 negatives for approximately 150% of the normal processing time when using 100 ISO film. The action of moving highlight tones up the zone scale is called '**expansion**'. Shadow tones remain largely unaffected by increasing the processing time so the final effect is to increase the contrast of the final negative.

# Calibration tests

The following additional tests can be conducted to check the accuracy of exposure and processing time.
*Note: Changing printing papers or type of enlarger (diffusion or condenser) will change the tonal range and contrast that can be expected and so therefore should be avoided.*

## Exposure

The exposure index is calibrated by checking the accuracy of shadow tones on the negative. This can be achieved by using a '**densitometer**' or by conducting the following clip test.

- ~ Underexpose a grey card by three stops (Zone II).
- ~ Leave the adjacent frame unexposed.
- ~ Process the negatives according to the manufacturer's specifications.
- ~ Place half of each frame (unexposed and Zone II ) in a negative carrier.

- ~ Make a step test using a normal contrast filter or grade two paper.
- ~ Establish the minimum time to achieve maximum black (MTMB).
- ~ The tone alongside the MTMB Should appear as Zone II (nearly black).

MTMB 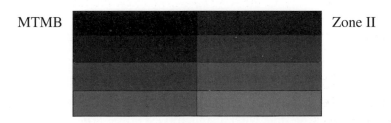 Zone II

If the adjacent tone to the MTMB exposure on the test strip is too light (dark grey), decrease the processing time. If the adjacent tone to the MTMB exposure on the test strip is too dark (black), increase the processing time.

# Processing

Processing is calibrated by checking the accuracy of the highlight tones on the negative. This can be achieved by using a '**densitometer**' or by conducting the following clip test.

~ Overexpose a grey card by three stops (Zone VIII).
~ Leave the adjacent frame unexposed.
~ Process the negatives according to the manufacturers specifications.
~ Place half of each frame (unexposed and Zone VIII ) in a negative carrier.

~ Make a step test using a normal contrast filter or grade two paper.
~ Establish the minimum time to achieve maximum black (MTMB).
~ The tone alongside the MTMB Should appear as Zone VIII (light tone).

MTMB  Zone VIII

If the adjacent tone to the MTMB exposure on the test strip is too light (paper white), decrease the processing time. If the adjacent tone to the MTMB exposure on the test strip is too dark (Zone VII), increase the processing time.

# Activity 4

Choose a 100 and 400 ISO film and conduct the exposure and processing tests as outlined on these pages.
Discuss your findings with other students.

# Perfecting the system

For accurate previsualisation the photographer must be familiar with **all** the materials and equipment in the chain of image creation. A common mistake is choosing a few very dark shadows to place in Zone III and the brightest highlights to place in Zone VII. The result may be a flat low-contrast image with the majority of the image placed in only three zones. Each time the system is operated the individual's ability to accurately previsualise the outcome improves.

## Summary

- Take a reflected meter reading of a shadow tone.

- Place in zone III by closing down two stops.

- Take a reflected meter reading of a highlight tone.

- Calculate how many stops brighter the highlight is than the shadow.

- Calculate the processing time using the information below.

---

**Average processing adjustments for 100 ISO film**

| Contrast | | Processing time % |
|---|---|---|
| Highlight 6 stops brighter than Zone III | N+2 | 150 |
| Highlight 5 stops brighter than Zone III | N+1 | 130 |
| Highlight 3 stops brighter than Zone III | N−1 | 85 |
| Highlight 2 stops brighter than Zone III | N−2 | 75 |

---

# Activity 5

Revisit the location you photographed in Activity 1 at the same time of day with the same lighting (directional sunlight required).
Using the zone system create an image with a full tonal range.
Choose the shadow and highlight details you wish to place in Zones III and Zone VIII.
Expose, process and print the negative to obtain the final image.
Compare the results achieved in this activity with the image created for Activity 1 and discuss the visual qualities with other students.

# Revision exercise

Q1.  How many zones are there in the zone system?

Q2.  Describe what the term '**previsualisation**' means?

Q3.  List the benefits and the limitations of using the zone system.

Q4.  What relevance does the '**18% grey card**' have to the zone system?

Q5.  What is '**zone placement**'?

Q6.  How many stops difference are there in between Zone III and Zone VIII?

Q7.  If shadow detail is missing on the normally processed negative (clear film base), would increasing the processing time restore the shadow detail?

Q8.  Describe the appearance of a typical Zone III and Zone VIII in a final print.

Q9.  How do you establish an exposure index of a black and white film?

Q10.  Does increasing the processing time of a film increase or decrease the contrast?

Q11.  If the metered shadow reads f4 @ 1/125 second and the metered highlight reads f22 @ 1/125 second how would you expose and process the film to achieve a full tonal range print?

# Resources

*Beyond the Zone System - Phil Davis.* Focal Press. London. 1998.
*Photography - London and Upton.* Harper Collins College Publishers. New York. 1994.
*The Negative - Ansel Adams.* Little, Brown. Boston. 1988.
*The Practical Zone System - Chris Johnson.* Focal Press. 1994.
*The Zone System for 35mm Photographers - Carson Graves.* Focal Press. London. 1997.
*The Zone System manual - Minor White.* Hastings-on-Hudson. New York. 1968.

# Gallery

*Alan Fredes*

*Kate Tan*

# Creative Techniques

*John Child*

## Aims

~ To develop knowledge and understanding of how light can change the character and mood of subject matter.
~ To develop skills in controlling lighting to achieve creative effect.

## Objectives

~ **Research** - Produce research in your visual diary that looks at a broad range of images utilising creative lighting techniques.
~ **Discussion** - Exchange ideas and opinions with other students on the work you are studying.
~ **Practical work** - Produce photographic transparencies that demonstrate a practical understanding of the creative lighting techniques in this study guide.

# Introduction

The choice, arrangement and design of a subject within the frame determines the effectiveness of its communication. Communication can be increased by having a better understanding of the camera and its controls. Careful consideration is advised when using technical effects. Images are about communication and content and not about technique. Technique should never dominate the image.

## Exposure compensation

Exposure compensation is used to correct tonal values that would otherwise have recorded as too dark or too light. It is also used to record detail in highlights or shadows when the brightness range of the subject is high. The third reason exposure compensation is used is for creative effect. The creative process of photography sometimes requires an exposure that is **not** correct to produce the desired result. The degree of compensation is only limited by the photographer's imagination and the limitations of the film. Interesting results can be achieved by purposely underexposing or overexposing regardless of SBR.

## Silhouettes

An image described as a silhouette is the dark shadow or outline of the subject against a lighter background. A silhouette can be created by backlighting the subject and reducing the exposure sufficiently to remove detail from the subject. Reducing the appropriate exposure for the subject by approximately two to three stops is usually sufficient to record the subject as black.

*Temple of the Emerald Green Buddha, Bangkok*

# Colour saturation

Decreasing exposure by 1/3 or 2/3 of a stop will increase colour saturation. This works especially well when using colour transparency as the processed image is viewed by light being transmitted through the film. The technique works well in flat midday light. Images can look underexposed if the photographer is recording tones of known value.

# Backlighting

A subject is back lighted when the dominant light is from behind the subject. To take a reflected reading of the subject from the camera would give an incorrect exposure. A reflected reading of the subject only or an incident reading from the subject to the camera would give correct exposure. The dominance of the backlight can therefore be controlled by exposure compensation.

# Halos

With subjects that have a extreme contrast either as a result of SBR or lighting ratios, exposing for the shadow areas will create the effect of massively overexposing the highlights. On its own or combined with lens filtration (soft filter) the result, especially when using a strong backlight, is a halo effect around the subject.

*Charanjeet Wadhwa*                                          *Thuy Vuy*

# Activity 1

Using tungsten colour transparency create the effect of a halo using a dominant backlight and exposure compensation.

Repeat the procedure to create two silhouettes with an interesting profile. One silhouette should have a white or clear background and the second should utilise the colours of an evening sky.

Bracket the reduced exposure compensation for each and label the results.

Process the roll of film and label the results of each frame.

Record all details in your Computation Book.

## Low key

A low key image is one where the dark tones dominate the photograph. Small bright highlights punctuate the shadow areas creating the characteristic mood of a low key image. The position of the light source for a typical low key image is behind the subject or behind and off to one side, so that the deep shadows are created. Highlights are created around the rim of the subject. The decision concerning appropriate exposure usually centres around how far the exposure can be reduced before the highlights appear dull. The shadow areas are usually devoid of detail when this action is taken unless a certain amount of fill is provided.

*Thuy Vuy*

*Laura Humphryis*

## High key

In a high key image the light tones dominate. Dark tones are eliminated or reduced by careful choice of the tonal range of the subject matter. Soft diffused lighting from a broad expansive light source is used to reduce shadows. Backgrounds may be flooded with light so that little detail is seen. Increased exposure ensures that all the tones are predominantly light. Hard edges and fine detail may be reduced by the use of a soft focus filter. A bright background placed close to the subject may also soften the outline of the form. The main light source to illuminate the subject can be provided by skylight, window light or light reflected off a large bright surface. Backgrounds can be overexposed by sunlight.

## Activity 2

Create one high key and one low key image.
Describe the lighting used for each image including a record of the indicated exposure and degree of compensation.

# Illusion of movement

Closely associated with an understanding of the use of light is the use of the camera to create the illusion of movement.  By combining the movement of either the camera, subject, or lights the illusion of movement within a still frame can be created. Using tungsten light in a darkened studio and with the camera lens open, walking slowly through frame (the camera's field of view) will result in a blurred image where you were moving and still image where you stopped.  Another way to create movement is to increase exposure time to the longest possible with the light source you are using and move the camera during all or part of the exposure.  This is easily achieved with a zoom lens, but also achievable by panning or tilting the camera mounted of a tripod.  There other advantages to using a slow shutter speed when using a combination of flash and tungsten.  If the output of the modelling lamps, or supplementary tungsten lighting, is high enough to equal the exposure aperture of the flash output a slower exposure time can be used for the tungsten light than that required for the flash.  This would allow correct exposure of the flash (which is regulated by aperture and not time) and correct exposure of the tungsten (which is regulated by a combination of aperture and time).  This would give the effect when using daylight film of a warm after glow to any object that moved before or after the flash exposure.

*Gary Gross*

# Activity 3

Load a camera with tungsten colour transparency film.

Light a person with a broad diffuse tungsten light from the same position as the camera.

Set the shutter to the longest exposure possible relative to the aperture.

In a darkened studio with the lens open get the subject to walk around in frame.  Vary the speed and rhythm of the movement.

Process the film and compile results and information in your Computation Book.

# Revision exercise

Q1.    Under exposing by three stops a subject lighted by a strong backlight will create which effect?

Q2.    Colour saturation can be increased by reducing exposure by how many stops?

Q3.    Describe the main differences between high key and low key images?

Q4.    How can a photographer ensure correct exposure of a strongly backlighted subject?

Q5.    To increase colour saturation of transparency film would a photographer increase or decreases exposure?

Q6.    'Technique should never dominate an image'.  What does this mean?

Q7.    What filtration can be used to increase a halo effect?

Q8.    What degree of shadow detail could be expected in a low key image?

Q9.    What degree of highlight detail could be expected in a high key image?

Q10.  To increase the illusion of movement would a photographer increase or decrease exposure time?

# Resources

*American Cinematographer Manual.*  ASC Press.  Hollywood.  1993.
*Basic Photography - Michael Langford.*  Focal Press.  London.  1997.
*Essential Skills: Studio Photography - John Child.*  Focal Press.  London.  1999.
*Essential Skills: Location Photography - Mark Galer.*  Focal Press.  London.  1999.
*Kodak Professional Products.*  Kodak (Australasia) Pty. Ltd.  Melbourne.  1998.
*Light Science and Magic - Fil Hunter and Paul Fuqua.*  Focal Press.  Boston.  1997.
*Photographing in the Studio - Gary Kolb.*  Brown & Benchmark.  Wisconsin.  1993.
*Photography - Barbara London and John Upton.*  Harper Collins.  New York.  1994.
*The Focal Encyclopedia of Photography.*  Focal Press.  London.  1993.
*The Image - Michael Freeman.*  Collins Photography Workshop.  London.  1990.

# Gallery

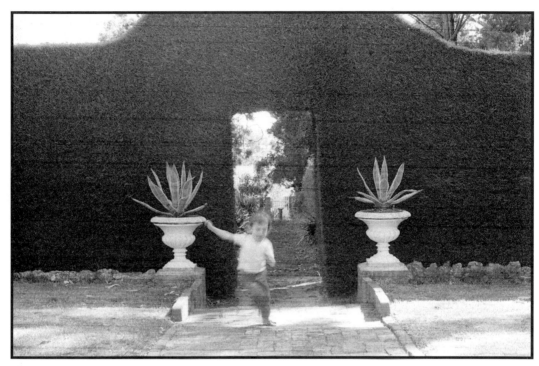

*John Child*

*Russell Shayer*

*Coralie Ryan*

# Gallery

*Hugh Peachey*

*RMIT*

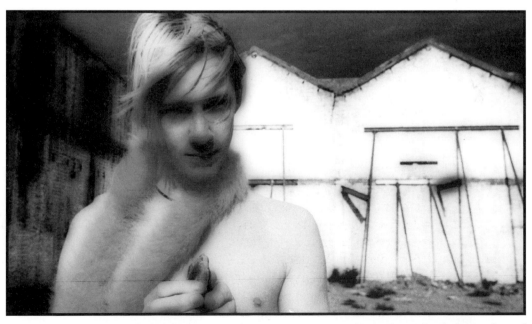

*Antonius Ismael*

# Studio Lighting

*RMIT*

## Aims

- ~ To develop knowledge and understanding of the use of artificial light sources, camera and associated equipment in a studio environment.
- ~ To develop an awareness of the effect of artificial light in the creation and control of lighting ratios, shade, contrast and exposure.

## Objectives

- ~ **Research** - Produce a Visual Diary that contains all the reference material gathered in completing the activities, and all visual information that influenced the approach taken when producing the photographs for each activity.
- ~ **Discussion** - Exchange ideas and opinions with other students and lecturers related to the photographs you intend to research and produce.
- ~ **Practical work** - Produce photographic colour transparencies of the still life, portraiture and fashion assignments.
- ~ Compile a Computation Book giving all information relevant to the technique and production of each photograph.

# Introduction

This study guide should be used as a practical source of information to understanding the use of tungsten light and flash in a studio situation. The explanation of how to use the two light sources (floodlight and spotlight) around which this study guide is centred is directly related to providing practical lighting solutions to the activities. It will also provide a basis for completion of the structured assignments in the study guide '**Essential Skills: Studio Photography**'. It is advisable that the technique and lighting approach suggested in each activity be followed at a group level with all students helping to recreate a single lighting set up. Upon completion individual students should then adapt the result to their own subject matter.

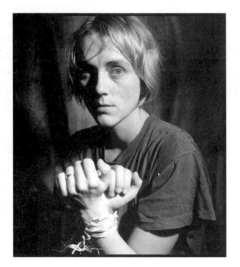

*Dianna Snape*                              *Michael Davies*

# Approach

The sun, the dominant light source in the world outside the studio, is the starting point in understanding studio lighting. As you progress through your photographic career other approaches will inevitably influence you but an understanding of how to use a single light source to achieve many varied results is a discipline worth mastering. Try not to attempt too much too soon.

Set yourself goals you know you can achieve within your limitations. Students never have enough time or money but admirably they are exploding with ideas. It is making these ideas work within the constraints and abilities of each student that will give successful results. Set out to achieve what you know is possible, use all the time available and exercise **patience**. Every time you move a light or alter its quality you will learn something. You will never take the perfect photograph. If you ever think you have change careers because photographically the learning process has ceased.

# Studio lighting

In a photographic studio all light has to be created by the photographer. An artificial light source can be anything from a large 10kW tungsten lamp to a single candle. These light sources fall into four main categories.

- ~ **Photoflood**
- ~ **Tungsten-halogen**
- ~ **AC Discharge**
- ~ **Flash**

## Photoflood (3400K)

The photoflood is similar in design to the normal domestic light globe. It is correctly balanced to tungsten film and normally used without correction. If used with daylight colour film an orange colour cast will be evident. This can be corrected with the use of a blue (80B) filter. When used with black and white film slight underexposure will occur. As the name implies this type of lamp is used when a broad, soft light source is required.

## Tungsten-halogen (3200K)

The most commonly used photographic artificial light. Light is emitted as the element inside the glass envelope is heated and provides a continuous source of light. All tungsten light forms emit a great deal of heat when operating. Will give correct colour when used with tungsten film. With daylight film the orange cast can be corrected with a blue (80A) filter. These types of lamps are predominantly used in spotlights where a point source of light is required.

## AC discharge (5600K)

Referred to as HMIs, AC discharge lamps have a very high output but emit less heat than tungsten when operating. They will maintain correct colour balance throughout the life of the lamp and will render correct colour when used with daylight film. When used with tungsten film an orange (85B) filter is required to remove the excess blue that theses lights emit. HMIs are used predominantly in the film industry and in studio car photography.

## Flash (5800K)

Flash is a generic term that refers to an artificial light source of high intensity and short duration. It will render correct colour when used with daylight film. Used with tungsten film an orange filter (85B) would be required to remove the blue cast. There is minimal heat output, and it maintains constant colour balance and intensity. To assess the direction and quality of the light flash heads have built in tungsten modelling lamps. As the output and intensity of the flash is far greater than that of the modelling lamps, exposure times will be too short for any tungsten exposure to register.

# Health and safety

## Power supply

It cannot be stressed strongly enough that the lighting equipment and studio power supply be either installed, or checked in the case of existing supply, by a qualified and licensed electrician. **Without question working with powered light sources is the most dangerous part of a photographers job.** As a photographer it is inevitable that light sources are taken for granted and unfortunately familiarity leads to complacency and poor safety practices.

~   Electricity is dangerous.  It can kill you.
~   Never attempt to repair lights or wiring unless you are absolutely confident that you know what you are doing.
~   Always turn off the power and disconnect the cable before changing a lamp.
~   Never touch any part of a light or cable with wet hands.
~   Exercise extreme care when photographing liquids.
~   Always turn off the power to the flash pack when changing flash head outlets.
~   Always be cautious when moving or connecting lights.
~   Use heat resistant gloves when handling tungsten lights.
~   Wear shoes with rubber soles.
~   Ensure all students know **where and how** to use the first aid kit.
~   Ensure all students know **where and how** to use the fire extinguisher.
~   Ensure all students are aware of emergency procedures related to work area.
~   Ensure adequate ventilation of the studio area.

*RMIT*                                              *Joshua Poole*

# Light sources

## Tungsten

Vacuum tungsten lamps and their derivatives, are widely used forms of artificial photographic lighting in photography, film and television. They have a colour temperature between 3200K - 3400K and are compatible with tungsten colour film and any black and white film. Despite the extensive use of flash in a commercial studio, prior to any flash exposure the way a subject is lighted has usually been determined by the tungsten modelling lamps built into the flash heads. The flash gives a much shorter exposure time but little advantage in the quality of light over the same subject having been lighted by appropriate tungsten light sources. Compared to flash, tungsten is simple technology. There are many variations upon the two basic tungsten light sources, but in general terms they all fall in to two major categories, floodlight and spotlight.

## Floodlight

A floodlight produces a wide flood of light across a subject. The light from the globe bounces off the reflector in which it sits and travels forward as a broad light source. This diffuse light gives 'soft' edges to the shadows and some shadow detail. The quality of the light is similar to that of sunlight through light cloud.

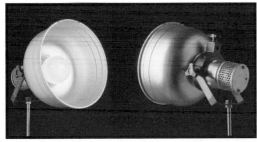

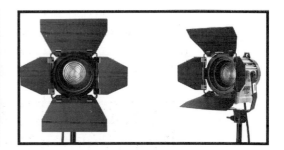

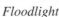

*Floodlight*                                                        *Spotlight*

## Spotlight

A spotlight can concentrate light at a certain point. The light from the lamp is directed forward by a hemispherical reflector and focused to a point by the glass Fresnel lens. The light will have 'hard' edges to the shadows and no detail in the shadow areas. The quality of the light is similar to direct sunlight. Spotlights can be flooded to give a more diffuse quality. This change from spot to flood is achieved by moving the lamp and the reflector inside the lamp housing away from (spot) or closer to (flood) the lens at the front of the light. On 'full spot' shadows are harsh with no detail, on 'full flood' shadows are softer with some detail. Most spotlights come with barn doors and nets. Barn doors are four metal flaps attached to the front of the light and used to control the shape and amount of light. Nets are pieces of wire gauze of varying densities that reduce the output of the light by diffusing the light at its source. They are manufactured in half and one stop increments.

# Flash

Flash is a generic term that refers to an artificial light source of high intensity and short duration. It has a colour temperature of 5800K and is compatible with daylight colour film and any black and white film. Unlike tungsten it is not a continuous source of light. Between flashes it has to recycle (recharge) back to maximum output before it can be used again.

A large tungsten lamp has an output 100 times greater than the average household light bulb. With a film rated at 100 ISO this will give exposures of around 1/60 second at f4. A modest studio flash with an output of 5000 joules placed at the same distance from the subject, as the tungsten lamp, will give exposures of around 1/500 second at f11. This is six stops faster or a ratio of 64:1. Its advantage when photographing anything that moves is obvious.

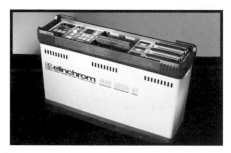
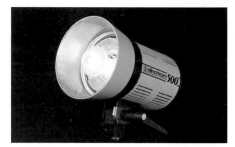

*Power pack*                                    *Flash head*

The advantage of modern flash is its lightweight construction and versatility. Most studio flash systems consist of the power pack, flash heads and flash head attachments. The power pack is usually a separate unit where the power output is stored until the instant of exposure. After exposure the power pack recharges ready for the next exposure. Recycling times vary from seconds to fractions of seconds. The faster the recharge to full power the more expensive the unit. The flash heads are the actual light source. The basis of their design is to produce light similar to that produce by floodlights and spotlights. The way in which this is achieved ranges from varying sizes of reflector bowls similar in design to a floodlight to a focusing spotlight equivalent to its tungsten counterpart. The choice of flash head attachments is as broad as that available for tungsten light. Apart from some examples of portraiture, all photographs in this book were lighted using tungsten light. This is not to underestimate the importance of flash in a studio situation. Tungsten lighting is however a far less expensive source of studio lighting, more resilient to student use and has lower maintenance costs. The lessons learned with one light source apply equally to any other.

# Activity 1

Using various resource material compile a collection of studio photographs that have used tungsten or flash as a light source. Divide into the two categories.

Discuss with lecturer and other students why that particular type of light source was used, its advantages and the difference in the result if the other type had been used.

# Floodlight

Despite the manufacturers names, swimming pool, soft box, fish fryer and many others, these are really only larger or smaller versions of a floodlight. In some the light source is placed inside and to the rear of a collapsible tent with direct light transmitted through a diffuse front surface. In others the light is reflected off a white or silver surface before it is transmitted through a diffuse front surface. These types of light sources give a very soft diffuse light with minimum shadows.

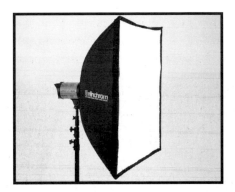

*Soft box*

Another source of soft diffuse light is created when flash is used in conjunction with a collapsible umbrella. With umbrellas that have a white or silver (inside) surface, light can be directed into the umbrella and reflected back onto the subject. With umbrellas that have a transparent diffuse surface light can be directed at the subject through the umbrella. This can give a harder light than the reflected light from the white umbrella.

*Reflected umbrella*            *Diffuse umbrella*

# Spotlight

The use of an open flash (direct light to subject without diffusion or reflection) will give the same effect as a spotlight. Some brands have focusing capabilities that closely imitate Fresnel spotlights. The light will be hard with no shadow detail. Barn doors, nets and filtration of the light source is approached in exactly the same way as a tungsten source.

# Mixed light sources

Any source of light can be combined with another to create interesting lighting effects and shifts in colour balance. In a studio situation this can go beyond mixing tungsten with flash and is limited only by one's imagination. Normal domestic lamps are often used as supplementary and practical sources of light. Candles give a warm glow and very soft shadows. Torch light can be used to great effect when painting with light. When working in colour do not be afraid to change the colour of the light by the use of coloured gels over the lights or filtration of the camera. If it gives off light, try using it!

*Mahesh Haris*

# Activity 2

Load a camera with tungsten colour transparency (64 ISO). Place the camera on a tripod and attach a cable release. Focus on coin placed on a dark background. Set the shutter speed to T (the aperture opens when the cable release is activated and will not close until the cable release is activated for the second time). Set the aperture to maximum aperture.

Turn off all studio lights and darken the studio.

Activate the cable release to open the lens.

Using a small torch with new batteries move the light from the torch over the coin as if you were painting it with a brush (large broad strokes) for approximately ten seconds. This should be done from the camera position.

Bracket your exposures by one stop either side of normal (5 seconds and 20 seconds).

Repeat this procedure at every aperture.

Note all details and process film.

Compile results and information in your Computation Book.

# Working with studio lights

## Common rules

Common rules of physics apply to the use of artificial light sources. When sunlight passes through greater amounts of particles in the atmosphere at dawn or sunset, exposure times increase compared to a reading taken at noon. This applies to clear and overcast days. Exposure times will obviously be shorter on a clear day. Applying these rules to a studio situation, the greater the impedance to the light (diffusion, reflection, filtration) the longer the exposure. The more direct the light (no diffusion, reflection, filtration) the shorter the exposure.

Another simple rule. The amount of light falling on a subject decreases to 1/4 of its original intensity when the light to subject distance is doubled, and increases by 4x when the light to subject distance is halved. For example, if a reading of f16 is obtained when the light to subject distance is one metre, at two metres the reading would be f8, at four metres f4. These rules do not change regardless of the light source. It is also important to remember that contrast in a studio situation is created not only by the reflectance level of the subject matter (SBR) but also by lighting ratios. When referring to lighting ratios the photographer is also referring to lighting contrast. See "**Contrast and Compensation**".

 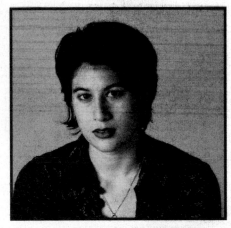

*Light one metre from subject - f16*          *Light two metres from subject - f16*

## Activity 3

In a darkened studio place a flood light one metre from the studio wall and take an incident reading, with the light on, of the light falling upon the wall.

Note the reading and move the light on the same axis another one metre, making a total of two metres away from the wall.

Note the reading. Double the distance once more, making a total of four metres.

The final reading will be four stops less than the first.

What will the distance of the light from the wall have to be to achieve a meter reading of three stops less than the first?

# Diffusion

Long before the invention of photography painters had been diffusing light. Light passing through certain materials created a light with soft shadows that were sympathetic to their subjects. Early writings and drawings of Michelangelo show that his studio had a type of cheesecloth hung over the windows. This diffused the harsh sunlight and filled the studio with a soft light more suitable to painting. Any light source can be diffused by placing certain translucent materials between the light source and the subject. This has the effect of diffusing and spreading the light over a greater area by altering the direction of the light waves. Diffusion softens the edges of the shadows and increases shadow detail. At the same time the measured amount of light falling on the subject is decreased. The amount of diffusion is also determined by where the diffusion material is placed in relation to the light source and the subject. The closer the diffusing material to the light source the less diffuse the light. The closer the diffusing material to the subject the more diffuse the light, the softer the edges of the shadows and the greater the shadow detail. There are many diffusion products manufactured specifically for the photographic market. These are products such as scrim, nets, and silks. Other suitable materials are tracing paper, cheesecloth, and window netting.

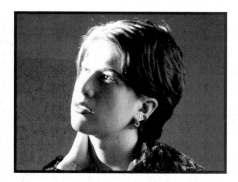 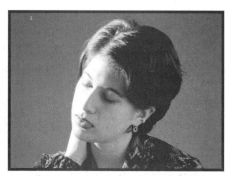

*Normal spotlight*                    *Diffused spotlight*

# Activity 4

In a darkened studio light a semi-reflective object (e.g. a tomato) with a floodlight from one side. Place the light approximately one and a half metres from the subject.
Observe the source of light reflected in the object and lack of shadow detail.
Diffuse the light source with tracing paper (60cm x 60cm) approximately 50cm from the light.
Observe the apparent increase in the size and diffusion of the light source as reflected in the subject, diffusion of the shadow and increase in shadow detail.
Without moving the light place the tracing paper as close to the subject as possible.
The light source has now become the size of the piece of tracing paper . There will be a soft spread of light over most of the subject with the shadow being almost nonexistent.
Repeat this procedure using a spotlight on full spot and then on full flood.
Observe the changes in the light source as you move the light from spot to flood.

# Reflection

Reflected light is most often used as a way of lighting areas the dominant light source (key light) cannot reach.  An example is the strong shadow created by a spot light when it is to one side of the subject.  To obtain detail in the shadow area light has to be reflected into the shadows.  This is called fill light and is achieved by collecting direct light from the light source and redirecting it with a reflector.  Reflectors can be any size, from a very small mirror to large polystyrene sheets measuring 2.5m x 1.5m.

Reflected light can also be used as the key light.  When photographing a reflective object, or a very diffuse (soft) lighting effect is required, the tungsten light source can be directed into a reflector.  The reflector becomes the light source and no direct light from the tungsten source is directed at or reflected in the subject.

When photographing cars in an exterior situation the car is usually positioned so that sunrise or sunset is behind the car.  With the sun below the horizon, the sky above and in front of the car is acting as a giant reflector.  This is one approach to lighting cars and reflective objects in a studio.

There are many reflective products available that are manufactured specifically for the photographic market.  Other more readily available materials are, white card, grey card, coloured card, silver foil, aluminium foil, and mirrors.

*Reflector as fill*                    *Reflector as light source*

# Activity 5

Light a person's face with a spotlight on full spot from behind and towards one side.
Observe the deep shadows that fall across most of the face.
Using a reflector (white card 1m x 1m) redirect the light from the spotlight falling onto the reflector into the shadow areas of the face.
Using colour transparency film record how the intensity of the light changes as the reflector is moved closer to and further away from the face.
Cover the reflector with aluminium foil and repeat the above activity.
Label and keep results for future reference.

# Filtration

Filters alter the light by selectively transmitting certain colours or changing the way light waves travel. A red filter only transmits red light. A blue filter only transmits blue light and so on. A soft focus filter changes the direction of the light waves in the same way as diffusion material softens a light source. Correction filters alter the colour temperature of the light to make it compatible with the film being used. Neutral density filters reduce the amount of light, and therefore exposure, from a light source without affecting its colour temperature. Glass, plastic and gelatin filters are used for filtration of the camera lens but gelatin filters are used more often in the filtration of the light source. The advantage of filtering the light source is that different filters can be used on each of the lights whereas with filtering the camera all light entering the lens will be subjected to a common filter. Filters used upon a light source are made of heat resistant coloured gels manufactured to specific safety requirements and colour balance. The effect of filtration is obvious and immediate. When working with correctly colour balanced gels, appropriate colour film and correct exposure '**what you see is what you get**'. When using colour filtration with black and white film a simple way of remembering the affect of a certain filter is that it will lighten its own colour and darken all others. Filtration of the camera is normally used for colour correction of the entire image. This may be caused by the light source being incompatible with the film or to remove an excess of one colour inherent in the light source. With camera filtration there will always be some degree of exposure compensation.

*Un-polarised*                    *Polarised*

Polarising filters are invaluable in the control of unwanted reflections and increased colour saturation. This is because of their ability to selectively transmit certain wavelengths as they are rotated in front of the camera lens or light source. A wide range of 'effect filters' such as graduated and star burst are also available. They can produce some interesting results but should not be used as a substitute for the lack of an original idea or solution to a photographic problem.

# Activity 6

Load a camera with tungsten colour film. Collect together many different filters. Photograph a subject with an average SBR with and without each filter.
Note exposure, filter used and light source.
Process the film and compile results in your Computation Book.

# Lighting ratios

Light meters are often incorrectly called exposure meters. Exposure is only one part of its function. It can also be used for measuring lighting ratios and lighting balance. This is achieved by taking an incident reading of the light source from the subject. The meter is pointed at the light source to measure the amount of light falling on the subject from that specific light. If there is more than one light source each light can be measured independently by ensuring only one light source is on at any one time. In this way the ratios between the light sources can be measured. Understanding and controlling lighting ratios will help ensure that the SBR is within the film's latitude.

Lighting ratios and their relationship to film latitude is best demonstrated and understood at a practical level. Take for example a photographer using colour transparency film known to have a latitude of five stops. To make use of this information the photographer would try to light the subject to within this range. A five stop film latitude would allow a photographer to use a maximum lighting ratio of 32:1 (5 stops). This ratio would retain detail in the highlights and the shadows.

## Example 1

In a darkened studio a person is lighted with a single light source from the right-hand side at 90 degrees to the subject. An incident light meter reading is taken from the right-hand side of the person's face directly towards the light source. The aperture is f45 at a shutter speed of 1 second.

An incident light meter reading is taken from the left-hand side of the person's face directly towards the opposite side of the studio to where the light is placed. The aperture is f4 at a shutter speed of 1 second. This is a lighting ratio of 128:1 (7 stops).

To reduce this ratio another light or a reflector (fill) is placed on the left hand side of the subject. The fill is moved towards or away from the subject until an aperture reading no more than three stops lower in number than that from the main light source (f16) is obtained. This is now a lighting ratio of 8:1.

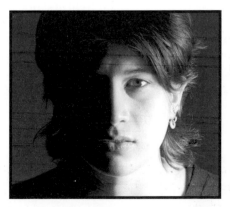

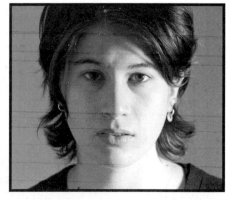

*128:1*                                                                                    *8:1*

# Example 2

A photographer has to light three sides of a single coloured box with a one stop ratio between each of the sides. Pointing a light meter in the general direction of the subject would give an average reading for 'correct' exposure but would not tell you the difference in the light falling on each of the three sides. This would be achieved by taking either a reflected reading of each side or for a more precise measurement taking an incident reading of each of the three light sources. This would give a measure of the actual amount of light falling on the subject. This information can then be used to adjust the balance of the lights to achieve the required lighting ratio.

*1. Spotlight*          *2. Spotlight +floodlight*          *3. Spotlight, floodlight + reflector*

1. In photograph one a point source (spotlight) is aimed at the top of a neutral grey box from behind the subject. The shadow falls forward of the subject. An incident reading is taken of the light source by pointing the invercone directly at the spotlight. The reading is f16.
2. In photograph two a diffuse source (floodlight) is aimed at the left side of the box, ensuring that no light affects the top or right side of the box. An incident reading is taken of the floodlight (shield the invercone with your hand to prevent light from the spotlight affecting the reading) by pointing the invercone directly at the floodlight. The reading is f11. This is a lighting ratio between the top and left hand sides of 2:1.
3. In photograph three a piece of white card is used to reflect light back into the right hand side of the box. The light reflected is gathered from the spotlight and floodlight. With both lights on, an incident reading is taken of the reflected light by pointing the invercone directly at the piece of white card. The reading is f8. This is a lighting ratio between the left and right sides of 2:1, and an overall lighting ratio between the top and left hand side of 4:1. To measure exposure an incident reading is taken by pointing the invercone from the front of the box back towards the camera. It should be f11. This is an average of the lighting ratio.

# Activity 7

Reproduce **Example 2** on tungsten colour transparency.
Photograph the progressive stages whilst working towards the correct lighting ratio.
Process film and compile with all relevant information in your Computation Book.
Discuss why the exposure is an average?

# Example 3

A photographer has to light a flower on a white background. The lighting ratio should be 4:1 between the background and the flower. Exposure compensation for a black tulip will be greater compared to the exposure for a yellow daffodil. The subject should be in focus, the background out of focus. The approach taken is the same as Example 1, using incident and reflected light meter readings to judge lighting ratio and final exposure.

*1. Floodlight*          *2. Spotlight*          *3. Floodlight + spotlight*

1. In photograph one place a flower on a sheet of white translucent perspex. Using a floodlight light the perspex from underneath. Centre the light behind the head of the flower. Adjust the light until the desired spread of light is achieved on the background. The background will appear white at the centre of the light graduating to various shades of grey towards the edges. Take a reflected reading of the centre of the light. Increase this exposure by two stops to give a tone that is almost white (e.g. f22 to f11). Record this exposure.

2. In photograph two turn off the background light. As viewed from the camera place a spot light slightly above and to the left of the flower. Between the spotlight and the flower hang a large sheet of tracing paper. Move the tracing paper closer to or further away from the flower until the desired effect is achieved (the light on the subject will be more diffuse the further the tracing paper is from light source). Take an incident reading from the flower of the light falling on the subject. Move the floodlight until a reading the same as the calculated exposure for the background is achieved This will render the flower as 18% grey and the centre of the background nearly white.

3. In photograph three turn on the background light. Check that the lighting ratio between the background and subject has not changed. Take an incident reading from the flower, back to the camera, of the light falling on the subject. If the flower is of an average mid-tone this will be correct exposure. If the flower is lighter or darker adjust the exposure accordingly, but remember to retain the same lighting ratio between subject and background, two stops or 4:1. Choose an exposure aperture that has sufficient depth of field to retain focus on the flower but no focus on the background.

# Example 4

A photographer has to create a mid key portrait with a predominance of average tones, and with no extreme highlights or shadows. The result is achieved using large, soft, very diffuse, even lighting, selective fill and overexposure by one stop to obtain correct skin tones. This is by far the most commonly used form of portraiture lighting. It is relatively simple to set up compared to high and low key lighting and will produce good results with most subjects. It does however lack drama and mood and would not enhance subjects with great physical character or delicacy of form.

*1. Soft box*          *2. Soft box+fill*          *3. Soft box+fill+back light*

1. In photograph one place the subject approximately two metres from a large diffusion screen (background). As viewed from the camera place a soft diffuse light source (flash soft box) in front of and to the left of the subject. Place a diffusion screen larger than the light source between the light source and the subject. The screen should be approximately one third of the distance from the light to the subject. Take an incident light meter reading from the subject to the camera. A typical reading would be f11 at 1/250 second.

2. In photograph two place a large (2m x 3m) white reflector in front of and to the camera right side of the subject. This will reflect light from the key light source back onto the right side of the subject. Adjust the distance of the reflector from the subject until an incident light meter reading from the subject to the reflector is one stop less than that obtained from the key light. This should be f8 at 1/250 second. This is a lighting ratio of 2:1 between the left and right sides of the face and when used for exposure will overexpose the left side of the face to reduce any skin imperfections.

3. In photograph three place behind the large diffusion screen in the background a large diffuse light source (flash soft box). Direct the light through the diffusion screen straight back at the camera. Adjust the light source so that an incident light meter reading taken from the subject to the diffusion screen in the background is two stops more than the incident reading of the subject to camera (f8 at 1/250 second). This background reading should be f16 at 1/250 second. If the subject exposure is set to f8 at 1/250 second the background will appear white.

# On location

The use of studio lights is not limited to the studio . They can be used just as successfully on location in conjunction with ambient and existing daylight. Combined with an understanding of colour correction of the light source or camera to balance with the film being used, most light sources can produce acceptable and interesting results.

## Exterior location

Common examples of studio lighting used on location are the images seen in film and television. The same approach can be taken to still images. Artificial light, whether flash or tungsten, is normally used to supplement the existing light present, usually daylight. In this situation correct colour balance is achieved by using daylight film (5500K) and filtering the tungsten light source/sources (3200K) with an 80A lighting gel. When using studio flash on location no filtration is required as the colour temperature of the flash is equal to average daylight (5500K). This would give 'correct' colour throughout the image.

## Mixed light

Another approach is to mix the colour temperature of the light sources to give a more 'natural' look. Despite the fact the human eye corrects all light sources to what appears to be white light, it is visually accepted, and in most cases to great effect, when we view mixed light sources on film, that there is a difference between the colour temperature of the various sources of light within the frame.

*RMIT*

# Interior location

There can be many different light sources with varying colour temperatures confronting the photographer on location. This can range from industrial lighting to the glow from a TV. The possibilities and variations are too many to cover in this Study Guide but the problems they pose can be corrected with filtration to render 'correct' colour, or the differences in colour temperature exploited and used to effect.

## Daylight film

In an exterior location all light sources and film are balanced to the predominance of daylight (5500K). With an interior location (for example a furnished room with large windows) there can be a mixture of various light sources. Using daylight film (5500K) without filtration of the tungsten light sources (3200K) would make the image appear quite different. Daylight in the image would appear 'correct' but any tungsten light source whether artificially introduced (studio) or practical (normal domestic lighting, desk lamps, candles, etc.) would create a warm glow at its source and on subject matter predominantly lighted by it. The overall effect on film would be of white light through the windows, and depending upon the lighting ratio created between the tungsten light and the ambient daylight an overall warm cast to the image.

## Tungsten film

If the photographer chose to use tungsten film (3200K) without filtration of either the daylight (5500K) or the tungsten light sources (3200K) the result would appear different again. Daylight in the image would appear to have a blue cast and any tungsten light source would appear 'correct'. The overall effect would be of blue light through the windows, and depending upon the lighting ratio created between the tungsten light and the ambient daylight, a balance of 'correct' colour within the room.

It should be remembered that filtration of the camera to match the dominant light source would also produce similar results to the above examples. However, filtration of the camera removes the possibility of selectively filtering the various light sources and colour temperatures available to the photographer to create an interesting mix of colours within the frame.

# Activity 8

Load a camera with tungsten colour transparency film.

Photograph a subject with average tones in an interior location where the ratio of daylight is greater than the artificial tungsten light.

Expose for the subject allowing the daylight to overexpose and record all relevant details.

Reverse the lighting ratio and again expose for the subject matter.

Place an 85B filter over the camera lens and repeat the procedure.

Process the film and collate the results with your written record.

Observe the differences in the results and compile this information in your Visual Diary.

# Revision exercise

Q1.   An incident meter reading of a subject with average SBR two metres from a light source is f11 @ 1/60 second.  What will the exposure be at 1/30 second if the light is moved another two metres further away from the subject?

Q2.   What happens to the quality and quantity of the light when a spotlight is moved from full spot to full flood?

Q3.   What affect does the colour temperature of tungsten light have upon of black and white film?

Q4.   What is the name given to the piece of optical glass used to bring a spotlight to focus?

Q5.   Barn doors can control the shape of a light source.  What attachment can control the intensity of the light?

Q6.   What are the advantages of diffusing a light source?

Q7.   Reflectors are primarily used to provide fill light to unlit areas of a subject. What is their other important use?

Q8.   A lighting ratio of 16:1 is a difference of how many stops between highlights and shadows?

Q9.   A polarising filter will have what affect upon tungsten colour film?

Q10.  Flash is a non-continuous light source.  What does this mean?

# Resources

*American Cinematographer Manual.*  ASC Press.  Hollywood.  1993.
*Arriflex Professional Products.*  Arriflex Corporation.  New York.  1998.
*Basic Photography - Michael Langford.*  Focal Press.  London.  1997.
*Elinchrom Professional Products.*  Elinca sa.  Renens, Switzerland.  1997.
*Essential Skills: Studio Photography - John Child.*  Focal Press.  London.  1999.
*Essential Skills: Location Photography - Mark Galer.*  Focal Press.  London.  1999.
*Kodak Professional Products.*  Kodak (Australasia) Pty. Ltd. Melbourne.  1998.
*Light Science and Magic - Fil Hunter and Paul Fuqua.*  Focal Press.  Boston.  1997.
*Photographing in the Studio - Gary Kolb.*  Brown & Benchmark.  Wisconsin.  1993.
*Photography - Barbara London and John Upton.*  Harper Collins.  New York.  1994.

# Gallery

Janette Pitruzzello

Charanjeet Wadhwa

Joanne Gamvros

Gary Gross

# Lighting on Location

*Mark Galer*

## Aims

~ To develop knowledge and understanding of how light can change the character and mood of subject matter.

~ To develop an awareness of overall subject contrast and how this translates to photographic film.

~ To develop skills in controlling introduced lighting on location.

## Objectives

~ **Research** - Produce research in your visual diary that looks at a broad range of fill and flash lighting techniques.

~ **Discussion** - Exchange ideas and opinions with other students on the work you are studying.

~ **Practical work** - Produce photographic positives through close observation and selection that demonstrate how lighting techniques control communication.

# Introduction

The lighting in a particular location at any given time may not be conducive to the effect the photographer wishes to capture and the mood they wish to communicate.  In these instances the photographer has to introduce additional lighting to modify or manipulate the ambient light present.  In some instances the ambient light becomes secondary to the introduced light or plays little or no part in the overall illumination of the subject.  The following conditions may lead a photographer towards selecting additional lighting:

~   The lighting may be too dull for the intended film and the resulting slow shutter speeds would cause either camera shake or subject blur.
~   Colour temperature of artificial lights causing undesired colour casts.
~   The ambient light is leading to an unsuitable brightness range for the film e.g. the contrast is too high for the latitude of the film and would lead to either overexposed highlights or underexposed shadows.
~   The direction of the primary light source is giving unsuitable modelling for the subject e.g. overhead lighting creating unsuitable shadows on a models face.

*St. Kilda market*

# Activity 1

Select four images created on location where you feel the photographer has used additional lighting to the ambient light present.

Discuss how and why you think the lighting has been changed to suit the communication.

# Fill

In high and extreme contrast scenes where the subject brightness range exceeds the latitude of the film it is possible for the photographer to lower the overall lighting ratio by supplying additional fill-light.  The two most popular techniques include using reflectors to bounce the harsh light source back towards the shadows or by the use of on-camera flash at reduced power output.  Before the photographer jumps to the conclusion that all subjects illuminated by direct sunlight require fill, the photographer must first assess each scene for its actual brightness range.   There can be no formula for assessing the degree of fill required when the subject is illuminated by direct sunlight.  Formulas do not allow for random factors which are present in some situations but not in others.  Photographers must, by experience, learn to judge a scene by its true tonal values and lighting intensity.

*Morocco*

The photograph above was taken in Morocco in harsh sunlight.  The photographer could be mistaken for presuming this is a typical scene which would require fill-light.  If the scene is read carefully however the photographer would realise that the shadows are not as dark as one would presume.  Meter readings taken in the shadows and highlights would reveal that the shadows are being filled by reflected light from the brightly painted walls.

# Reflectors

Fill-light can occur naturally by light bouncing off reflective surfaces within the scene.  It can also be introduced by reflectors strategically placed by the photographer.  This technique is often used to soften the harsh shadows cast on models in harsh sunlight. The primary considerations for selecting a reflector are surface quality and size.

## Surface quality

Reflectors can be matt white, silver or gold depending on the characteristics and colour of light required.  A matt white surface provides diffused fill-light whilst shiny surfaces, such as silver or gold, provide harsher and brighter fill-light.  Choosing a gold reflector will increase the warmth of the fill-light and remove the blue cast present in shadows created by sunlight.

## Size

Large areas to be filled require large reflectors.  The popular range of reflectors available for photographers are collapsible and can be transported to the location in a carrying bag.  A reflector requires a photographer's assistant to position the reflector for maximum effect.

Beyond a certain size (the assistant's ability to hold onto the reflector on a windy day) reflectors are often not practical on location.

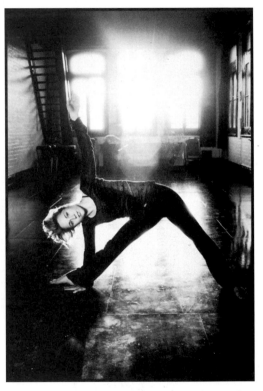

*Hugh Peachey*

# Activity 2

Select four examples where fill light has been used to soften the shadows created by a harsh direct light source.

Comment on the likely source of the fill-light.

Create two images using different reflectors to obtain different qualities of fill-light.

# Flash

Flash is the term given for a pulse of very bright light of exceptionally short duration. The light emitted from a photographic flash unit is balanced for daylight film and the duration of the flash is usually shorter than 1/500 second.

When the photographer requires additional light to supplement the daylight present flash is the most common source used by professional photographers. Although it can be used to great effect it is often seen as an incredibly difficult skill to master. It is perhaps the most common skill to remain elusive to students of photography when working on location. The difficulty of mastering this essential skill arises in the fact that the effects of the flash are not seen until the film is processed. The flash is of such short duration that integrating flash with ambient light is a skill of previsualisation and applied technique. The photographer is unable to make use of modelling lights that are used on studio flash units (modelling lights that can compete with the sun are not currently available). The skill is therefore mastered by a sound understanding of the characteristics of flashlight and experience through repeated application.

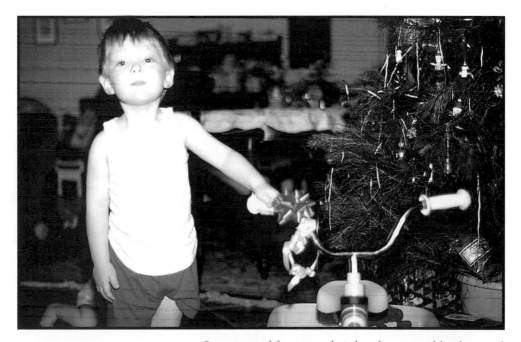

*Overexposed foreground and underexposed background*

## Characteristics

Flash is a point light source used relatively close to the subject. The resulting light is very harsh and the effects of fall-off (see "Characteristics of Light") are often extreme. One of the skills of mastering flash photography is dealing with and disguising these characteristics that are often seen as professionally unacceptable.

# Choice of flash

Choosing a flash unit for use on location may be decided on the basis of degree of sophistication, power, size and cost.

Most commercially available flash units are able to read the reflected light from their own flash during exposure.  This feature allows the unit to extinguish or 'quench' the flash by a '**thyristor**' switch when the subject has been sufficiently exposed.  When using a unit capable of quenching its flash, subject distance does not have to be accurate as the duration of the flash is altered to suit.  This allows the subject distance to vary within a given range without the photographer having to change the aperture set on the camera lens or the flash output.  These sophisticated units are described as either '**automatic**' or '**dedicated**'.

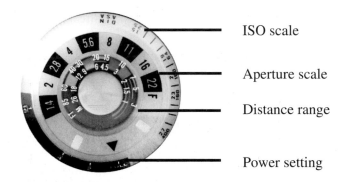

ISO scale

Aperture scale

Distance range

Power setting

*Control panel of an older style automatic flash unit*

## Automatic

An automatic flash unit uses a photocell mounted on the front of the unit to read the reflected light and operate an on-off switch of the fast acting thyristor type.  The metering system works independently of the cameras own metering system.  If the flash unit is detached from the camera the photocell must remain pointing at the subject if the exposure is to be accurate.

## Useful specifications

Perhaps the most important consideration when selecting an automatic flash unit is its ability to make use of a range of f-stops on the camera lens.  Cheaper units may only have a choice of two f-stops whereas more sophisticated units will make use of at least four.

Ideally the output of a professional unit will have a '**guide number**' (an indication of the light output) of 25 or more.  The amount of time the unit takes to recharge is also a consideration.  Many flash outfits have the option of being linked to a separate power pack so that the drain on the units smaller power supply (usually AA batteries) does not become a problem.

The flash head of a unit will ideally swivel and tilt allowing the photographer to direct the flash at any white surface whilst still keeping the photocell pointed at the subject.

# Dedicated

Dedicated flash units are often designed to work with specific cameras, e.g. Nikon 'speedlights' with Nikon cameras. The camera and flash communicate more information through additional electrical contacts in the mounting bracket of the unit. The TTL metering system of the camera is used to make the exposure reading instead of the photocell. In this way the exposure is more precise and allows the photographer the flexibility of using filters without having to alter the settings of the flash.

In addition to the TTL metering system the camera may communicate information such as film speed and the focal length of the lens being used. This information may be automatically set ensuring an accurate exposure and the correct spread of light.

Features such as automatic fill flash, slow sync, rear curtain slow sync, red eye reduction and strobe are common features of some sophisticated units. Often the manuals accompanying these units are as weighty as the manual for the camera which they are designed to work in conjunction with.

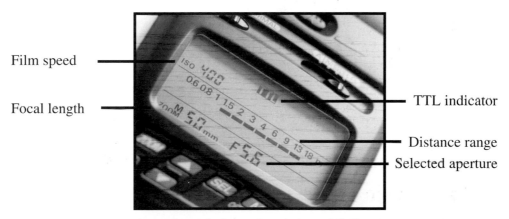

*Control panel of a modern dedicated flash unit*

# Setting up a flash unit

Check that the film's ISO has been set on the flash/flash meter and camera.

Check that the flash is set to the same focal length as the lens. This may involve adjusting the head of the flash to ensure the correct spread of light.

Check that the shutter speed on the camera is set to the correct speed (usually slower than 1/125 second on a 35mm SLR camera using a focal plane shutter).

Check that the aperture on the camera lens matches that indicated on the flash unit.

On dedicated units you may be required to set the aperture to an automatic position or the smallest aperture.

Check that the subject is within range of the flash. On dedicated and automatic units the flash will only illuminate the subject correctly if the subject is within the two given distances indicated on the flash unit. If the flash is set incorrectly the subject may be overexposed if too close and underexposed if too far away.

Check the accuracy of the flash output using a flash meter (see "**Guide numbers**" in this study guide).

# Guide numbers

Portable flash units designed to be used with small-format and medium-format cameras are given a '**guide number**' (**GN**) by the manufacturers.  This denotes its potential power output.  The guide number is an indication of the maximum distance at which the unit can be used from the subject to obtain an appropriate exposure.  The guide number is rated in metres using a 100 ISO film and an aperture of f1.  Because very few photographers possess an f1 lens the actual maximum working distance is usually somewhat lower than the guide number would suggest.

A unit given a guide number of thirty-two could correctly expose a subject at sixteen metres using an aperture of f2 (32 divided by 2 = 16).  If the lens was changed to one with a maximum aperture of f4, the maximum working distance would be reduced to 8 metres.  It therefore follows that if the guide number of the unit is known the correct exposure can be determined by dividing the guide number by the working distance.  The resulting figure is the aperture required when the flash is turned to manual full power (photocell effectively switched off).  For example a flash with a guide number of 32 used to expose a subject four metres away will require an aperture of f8.

---

**Distance from subject ✕ indicated aperture (MIE) = Guide number**

**Guide number ÷ aperture = Effective working distance**

**Guide number ÷ distance from subject = Correct aperture**

---

# Activity 3

Test the guide number of a flash unit using a hand-held flash meter.  The unit does not have to be attached to a camera.

Turn the flash unit to manual operation and full power.

Stand a measured distance from the flash unit e.g. four metres.

Attach an invercone to the flash meter's cell and set the film speed to 100 ISO.

Aim the flash meter at the unit and take an ambient reading of the flash (use a 'sync lead' or friend to manually trigger the flash using the test button).

Multiply the indicated aperture on the flash meter by the distance used, e.g. if the subject stands four metres from the flash and records a meter reading of f11 the guide number of the unit is 44.

# Flash as the primary light source

The direct use of flash as a professional light source is often seen as unacceptable due to its harsh qualities. The light creates dark shadows that border the subject, hot spots in the image where the flash is directed back into the lens from reflective surfaces and 'red-eye'.

## Red-eye

Red-eye is produced by illuminating the blood filled retinas at the back of the subject's eyes with direct flash. The effect can be reduced by exposing the subjects eyes to a bright light prior to exposure ('red-eye reduction') or by increasing the angle between the subject, the camera lens and the flash unit. Red-eye is eliminated by moving closer or by increasing the distance of the flash unit from the camera lens. To do this the lens must be removed from the camera's hot-shoe. This is called **'off-camera flash'**.

## Off-camera flash

Raising the flash unit above the camera has two advantages. The problem of red eye is mostly eliminated. Shadows from the subject are also less noticeable.

When the flash unit is removed from the camera's hot shoe the flash is no longer synchronised with the opening of the shutter. In order for this synchronisation to be maintained the camera and the flash need to be connected via a 'sync lead'.

For cameras that do not have a socket that will accept a sync lead a unit can be purchased which converts the hot shoe on the camera to a sync lead socket. If a dedicated flash unit is intended to be used in the dedicated mode a dedicated sync cable is required that communicates all the information between the flash and the camera. If this is unavailable the unit must be switched to either automatic or manual mode.

**Keep the photocell of an automatic unit directed towards subject during exposure.**

## Hot-spots

When working with direct flash the photographer should be aware of highly polished surfaces such as glass, mirrors, polished metal and wood. Standing at right angles to these surfaces will cause the flash to be directed back towards the cameras lens creating a hot-spot. Whenever such a surface is encountered the photographer should move so that the flash is angled away from the camera. It is a little like playing billiards with light.

## Activity 4

Connect a flash unit to your camera via a sync lead and set the unit to automatic.
Position a fellow student or friend close (within half a metre) to a white wall.
Hold the flash above the camera and expose several frames using colour transparency film at varying distances from the subject.
Repeat the exercise with the unit mounted on-camera.
Discuss the results commenting on the shadows and the presence of red-eye.

# Diffusion and bounce

If the subject is close or the output of the flash unit is high, the photographer has the option of diffusing or bouncing the flash. This technique will soften the quality of the light but lower the maximum working distance.

## Diffusion

Diffusion is affected by placing tissue, frosted plastic or a handkerchief over the flash head. Intensity of light is lowered but the quality of light is improved.

The flash can be further diffused by directing the flash towards a large, white piece of card attached to the flash head. Purpose made attachments can be purchased.

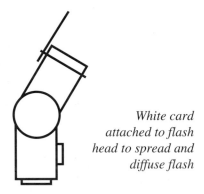

*White card attached to flash head to spread and diffuse flash*

## Bounce flash

The most subtle use of flash is achieved by directing the flash to a much larger, white reflective surface such as a ceiling for overhead lighting, or nearby wall for side lighting. This is called bouncing the flash. To obtain this effect the flash unit must have the ability to tilt or swivel its flash head. If this is not possible the flash can be removed from the hot shoe and connected to the camera via a sync lead. If an automatic flash is being used the photographer must ensure that the photocell is facing the subject when the flash is fired.

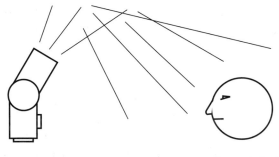

*Bounce flash*

# Activity 5

Use another student or friend holding the flash meter as your subject.

Diffuse the flash and record the adjusted GN of the unit. Expose two frames compensating for the reduced intensity of the flash.

Expose four frames of film using bounce flash at two different distances to the subject. Bounce the flash off a white ceiling or white reflector positioned to one side of the subject. Compare the quality of the light in the images produced above.

# Fill-flash

Fill-flash can be a very useful way of lowering the brightness range. Often the photographer is unable to reposition the primary subject and the addition of fill-light from the camera's position is essential to the image's success.

The aim of fill-flash is to reveal detail in the dark shadows created by a harsh directional light source. The aim is not to overpower the existing ambient light and remove the shadows completely. If the power of the flash is too high the light will create its own shadows creating an unnatural effect. Because the ambient light is still regarded as the primary light source any exposure dictated by the flash unit must also be suitable for the ambient light. The flash unit is mounted on the cameras hot shoe and the flash directed towards the subject. To retain the effect of the primary (ambient) light source the flash is most commonly fired at half or quarter power. The ratio of ambient to flash light is therefore 2:1 or 4:1.

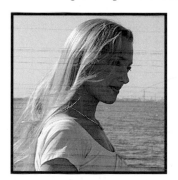 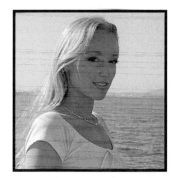 

*Ambient light only*                     *4:1 ratio*                     *1:1 ratio*

                                                               *Angela Nichols*

**Manual** - Select a smaller aperture on the camera from that indicated by the flash unit or flash meter, e.g. if the meter or unit indicates f5.6 select f8 or f11 on the camera.

**Automatic** - Many automatic flash units have the facility to fire at 1/2 or 1/4 power making fill-flash a relatively simple procedure. If this facility is unavailable set the film speed on the flash unit to double or quadruple the actual speed of the film to lower the output.

**Dedicated** - Many sophisticated cameras and dedicated flash units have a fill-flash option. This should be regarded as a starting point only and further adjustments are usually required to perfect the technique. Power often needs to be further lowered for a more subtle fill-in technique. The photographer may also wish to select a '**slow-sync**' option on the camera, if available, to avoid underexposing the ambient light in some situations.

## Activity 6

Lower the lighting contrast of a portrait lit with harsh sunlight using fill-flash.

Illuminate the subject from above, from the side and from the back.

Take three images for each lighting scenario setting the flash unit to full power, half power and quarter power.

Label the results and discuss the most favourable fill/ambient lighting ratio of each image.

# Flash as a key light

The main light in studio photography is often referred to as the '**key light**'.  Using studio techniques on location is popular in advertising and corporate photography where mood is created rather than accepted.  In this instance flash becomes the dominant light source and the ambient light serves only as the fill-light.

When the ambient light is flat directional light can be provided by off-camera flash.  This enables the photographer to create alternative moods.  The use of off-camera flash requires either the use of a '**sync lead**' or an infrared transmitting device on the camera.

## Slave units

Some professional flash units come equipped with a light-sensitive trigger so that as soon as a flash that is connected to the camera is fired the unconnected flash or '**slave**' unit responds.  On location the slave unit can be fired by the use of a low powered on-camera flash.

## Accessories

A tripod or assistant is required to either secure or direct the flash.

An umbrella or alternative means of diffusion for the flash may be considered.

Colour compensating filters may also be considered for using over the flash head.  A warming filter from the 81 series may be useful to create the warming effect of low sunlight.

## Technique

- Check the maximum working distance of the flash.
- Ensure the key light is concealed within the image or out of frame.
- Diffuse or bounce the key light where possible.
- Consider the effects of fall-off.
- Avoid positioning the key light too close.
- Establish a lighting ratio between the key light and ambient light.
- Consider the direction of shadows being cast from the key light.

When working at night the photographer may have the option of approaching the subject and firing a number of flashes manually during an extended exposure (recharging the unit each time).  The photographer or assistant must take care not to illuminate themselves during this process.

## Activity 7

Take six images using flash as a directional key light.

Record the subject using three different lighting ratios.

# Slow-sync flash

Slow-sync flash is a technique where the freezing effect of the flash is mixed with a long ambient light exposure to create an image which is both sharp and blurred at the same time. Many modern cameras offer slow-sync flash as an option within the flash programme but the effect can be achieved on any camera. The camera can be in semiautomatic or manual exposure mode. A shutter and aperture combination is needed that will result in subject blur and correct exposure of the ambient light and flash. To darken the background so that the frozen subject stands out more, the shutter speed can be increased over that recommended by the camera's light meter.

- ~ Load the camera with 100 ISO film or less.
- ~ Select a slow shutter speed that will allow camera movement blur (try experimenting with speeds around 1/8 second).
- ~ Take an ambient light meter reading and select the correct aperture.
- ~ Set the flash unit to give a full exposure at the selected aperture.
- ~ Pan or jiggle the camera during the long exposure.

*Emu*

## Possible difficulties

**Limited choice of apertures** - Less expensive automatic flash units can dictate the use of a limited choice of apertures. This can lead to a difficulty in obtaining the suitable exposure. More sophisticated units allow a broader choice of apertures, making the task of matching both exposures much simpler.

**Ambient light too bright** - If the photographer is unable to slow the shutter speed down sufficiently to create blur, a slower film should be used or the image created when the level of light is lower.

# Revision exercise

Q1.     State two reasons why you would choose to use a gold reflector on location whilst photographing a model on a sunny day.

Q2.     Describe the likely effect that you would see in the final image if you exceeded the recommended shutter speed whilst using flash on a 35mm SLR camera.

Q3.     A flash unit is switched to manual and fired at full power.  The flash meter reading taken six metres away indicates an exposure of f5.6.  What is the guide number of the flash unit?

Q4.     A flash unit with a guide number of thirty-six is switched to manual and fired at full power.  The distance to the subject is six metres and the photographer is using 400 ISO film.  What is the aperture required for a correct exposure?

Q5.     Describe how a photographer can reduce or eliminate the risk of red-eye?

Q6.     Explain the procedure you would need to take when lowering the SBR using an automatic flash unit?

Q7.     Explain the technique of using flash as a directional key light.

Q8.     An ambient reading at a location is metered as f8 @ 1/60 second using 200 ISO film.  It is decided to apply the technique of flash blur to the subject and that 1/8 second would be appropriate for the blur.  Describe the adjustments to the ambient exposure and the necessary flash exposure to create the required effect?

# Resources

*Basic Photography - Michael Langford.*  Focal Press.  London.  1997
*Black and White Photography - Rand/Litschel.*  West Publishing Co.  Minneapolis.  1994
*Encyclopedia of Photography.*  Crown Publishers.  New York.  1984.
*Photography - London and Upton.*  Harper Collins College Publishers.  New York.  1994.
*The Focal Encyclopedia of Photography.*  Focal Press.  London.  1993.

# Gallery

*Michael Davies*

*Michael Davies*

# Gallery

*Michael Mullan*

*Dianna Snape*

# Assignments

*RMIT*

## Aims

~ To develop and extend your knowledge and understanding of the application of studio and location lighting, filtration and camera technique.

~ To develop and extend your understanding of the practical use of light to create contrast, dimension, mood and to increase your creative ability to interpret a written brief with specific guidelines.

## Objectives

~ **Research** - Through thorough pre-production ensure that all the requirements to produce the images are available in the right place at the right time.

~ **Discussion** - Exchange ideas and opinions with other students and lecturers relevant to the creative content of the assignments being completed.

~ **Practical work** - Produce a series of photographs to the highest standard that fulfil the criteria set down in the assignment information plus personal creative interpretation.

# Introduction

The assignments in this study guide should be attempted after successful completion of the activies in the previous study guides. Creative interpretation of the written brief is strongly encouraged.  Assignments should be completed at an individual level in any order. Allowance should be made for the fact that each assignment may need photographing more than once before a satisfactory result is achieved.  Group tutorials should be the forum where technique and creative interpretation are discussed amongst students and lecturers.  Special attention should be taken of the medium in which the photograph is to be used. This will determine image format and in some cases composition. See "**Essential Skills: Studio Photography (Art Direction)**".

*Antonius Ismael*

This series of images should portray an understanding of what lighting and camera technique can achieve in changing the photographers perception of the subject and previsualisation of the image.  Avoid placing a subject on or against a background, taking a normal viewpoint and perspective and lighting for correct colour and exposure.  This is no different to documentation of the subject. As creative photographic illustrators much more is required. Experiment with viewpoint and lighting. Do not let reality get in the way of creative composition. Perspective, depth, dimension can all be altered to suit the design of the image.  The camera will 'see' and record anything you want it to.  This does not have to relate to human perception.  Separate subjects from the background.  Dispense with the concept of backgrounds altogether.  The area behind and around the subject is only limited by your imagination. **Previsualise, experiment and create.**

# 1.   Still life

Subject of your choice photographed at an interior location, making use of filtration and the available ambient light.  Any window and practical tungsten light source (desk lamp, etc.) should appear in the photograph.  To be used for a single page colour advertisement.

# 2.   Formal portrait

Subject of your choice photographed at an exterior location making use of artificial tungsten light or studio flash.  Vertical format suitable for exhibition.

# 3.   Time of day

Recreate in the studio an exterior photograph of a typical coffee restaurant table setting.  The time of day is either early morning (breakfast menu) or late afternoon.  Use colour filtration of the light source (flash or tungsten) to achieve the colour balance appropriate to the time of day.  To be used for single page colour editorial.

# 4.   Available light

A still life of a vase of flowers photographed on location (interior or exterior) using only the available light.  It should be photographed in the style of an impressionist painting.  Format and film choice appropriate to the subject matter and desired effect.

# 5.   Crowded street

A series of photographs of a single person in a crowded street to highlight the fact they are different to everyone else.  Use should be made of a long focal length lens, selective focus and ambient light.  Colour double-page spread.

# 6.   Environmental portrait

A series of environmental portraits of people at work, rest or play for an international confectionery manufacturer.  The people must be young, from various ethnic backgrounds and must always appear to be enjoying themselves.  Use a mixture of available and supplementary lighting.  Colour point of sale.

# 7.   Product shot

Studio product shot to complement the previous series of portraits.  The product should be obvious, yet sympathetic to the mood created by the portraits.  Colour transparency.

# 8.   Torchlight

Using torchlight only, light a subject of your choice in the studio or on location.  Experimentation with exposure and filtration is required to achieve a satisfactory result.

# Gallery

*John Child*

*Mahesh Haris*

*Antonius Ismael*

# Glossary

| | |
|---|---|
| **1K** | 1000 watts, measure of light output. |
| **2K** | 2000 watts, measure of light output. |
| **5K** | 5000 watts, measure of light output. |
| **10K** | 10000 watts, measure of light output. |
| **12K** | 12000 watts, measure of light output. |
| **120** | Film format. |
| **2 1/4** | 2 1/4 x 2 1/4". Camera format. |
| **35mm** | Camera and film format (24 x 36mm). |
| **500W** | 500 watts, measure of light output. |
| **5 x 4** | 5 x 4", camera and film format. |
| **6 x 4.5** | 6 x 4.5cm camera format. |
| **6 x 6** | 6 x 6cm camera format. |
| **6 x 7** | 6 x 7cm camera format. |
| **6 x 8** | 6 x 8cm camera format. |
| **6 x 9** | 6 x 9cm camera format. |
| **10 x 8** | 10 x 8 inches camera and film format. |
| **80A** | Conversion filter, daylight film to 3200K light source. |
| **80B** | Conversion filter, daylight film to 3400K light source. |
| **85B** | Conversion filter, tungsten film to daylight. |
| | |
| **AC discharge** | 5600K continuous light source. |
| **Ambient** | Available or existing light. |
| **Analyse** | To examine in detail. |
| **Aperture** | Lens opening controlling intensity of light entering camera. |
| **Arri 650W** | Arriflex 650 watt light source (3200K). |
| **ASA** | Film speed rating - American Standards Association. |
| **Auto focus** | Automatic focusing system, mainly small format cameras. |
| **Available** | Ambient or existing light. |
| | |
| **B** | Shutter speed setting for exposures in excess of 1 second. |
| **B/g** | Background. |
| **Background** | Area behind main subject matter. |
| **Backlight** | Light source directed at the subject from behind. |
| **Backlit** | A subject illuminated from behind. |
| **Balance** | A harmonious relationship between elements within the frame. |
| **Barn doors** | Metal shutters attached to light source. |
| **Bellows** | Light proof material between front and rear standards. |
| **Bellows extension** | When length of bellows exceeds focal length of lens. |
| **Bellows formula** | Mathematical process to allow for loss of light. |
| **Blurred** | Unsharp image, caused by inaccurate focus, shallow depth of field, slow shutter speed, camera vibration or subject movement. |

| | |
|---|---|
| **Bounce** | Reflected light. |
| **Bracketing** | Overexposure and underexposure either side of MIE . |
| | |
| **C stands** | Vertical stand with adjustable arm. |
| **C41** | Negative film process. |
| **Cable release** | Device to release shutter, reduces camera vibration. |
| **Camera** | Image capturing device. |
| **Camera shake** | Blurred image caused by camera vibration during exposure. |
| **Close down** | Decrease in aperture size. |
| **Closest point of focus** | Minimum distance at which sharp focus is obtained. |
| **Colour conversion** | Use of filtration to balance film to light source. |
| **Colour correction** | Use of filtration to balance film to light source. |
| **Colour temperature** | Measure of the relationship between light source and film. |
| **Compensation** | Variation in exposure from MIE to obtain appropriate exposure. |
| **Complementary** | Colour - see primary and secondary. |
| **Compound** | In lens design, indicating use of multiple optical elements. |
| **Compression** | Underdevelopment allowing a high contrast subject brightness range to be recorded on film.  See "The Zone System". |
| **Concept** | Idea or meaning. |
| **Context** | Circumstances relevant to subject under consideration. |
| **Contrast** | The difference in brightness between the darkest and lightest areas of the image or subject. |
| **Cord** | Electrical lead. |
| **Covering power** | Ability of a lens to cover film format with an image. |
| **CPU** | Central processing unit of a camera used to compute exposure. |
| **Cropping** | Alter image format to enhance composition. |
| **Cut-off** | Loss of image due to camera aberrations. |
| **Cutter** | Device used to control spread and direction of light. |
| **Cyclorama** | Visually seamless studio. |
| | |
| **Dark slide** | Cut film holder. |
| **Darkcloth** | Material used to give a clearer image on ground glass. |
| **Daylight** | 5500K. |
| **Dedicated flash** | Flash regulated by camera's exposure meter. |
| **Dense** | Overexposed negative, underexposed positive. |
| **Density** | Measure of the opacity of tone on a negative. |
| **Depth of field** | Area of sharpness variable by aperture or focal length. |
| **Depth of focus** | Distance through which the film plane moves without losing focus. |
| **Design** | Basis of visual composition. |
| **Diagonal** | A line neither horizontal nor vertical. |
| **Diaphragm** | Aperture. |
| **Differential focusing** | Use of focus to highlight subject areas. |
| **Diffuse** | Dispersion of light (spread out) and not focused. |

| | |
|---|---|
| **Diffuser** | Material used to disperse light. |
| **Digital** | Images recorded in the form of binary numbers. |
| **Digital image** | Computer generated image created with pixels, not film. |
| **DIN** | Film speed rating - Deutsche Industrie Norm. |
| **Dioptres** | Close-up lenses. |
| **Direct light** | Light direct from source to subject without interference. |
| **Distortion** | Lens aberration or apparent change in perspective. |
| **Double dark slide** | Cut film holder. |
| **Dynamic** | Visual energy. |
| **DX coding** | Bar coded film rating. |
| | |
| **E6** | Transparency film process. |
| **Ecu** | Extreme close up. |
| **Electronic flash** | Mobile 5800K light source of high intensity and short duration. |
| **Emulsion** | Light sensitive coating on film or paper. |
| **Equivalent** | Combinations of aperture and time producing equal exposure. |
| **Evaluate** | Estimate the value or quality of a piece of work. |
| **Expansion** | Manipulating the separation of zones in B & W processing. |
| **Exposure** | Combined effect of intensity and duration of light on light sensitive material. |
| **Exposure factor** | Indication of the increase in light required to obtain correct exposure. |
| **Exposure meter** | Device for the measurement of light. |
| **Exposure value** | Numerical values used in exposure evaluation without reference to aperture or time. |
| **Extreme contrast** | Subject brightness range that exceeds the film's ability to record all detail. |
| **EV** | Numerical values used in exposure evaluation without reference to aperture or time. |
| | |
| **F-stop** | Numerical system indicating aperture diameter. |
| **Fall** | A movement on large format camera front and rear standards. |
| **Fast film** | Film with high ISO, can be used with low light levels. |
| **Field of view** | Area visible through the camera's viewing system. |
| **Figure and ground** | Relationship between subject and background. |
| **Fill** | Use of light to increase detail in shadow area. |
| **Fill-flash** | Flash used to lower the subject brightness range. |
| **Film** | Imaging medium. |
| **Film speed** | Rating of film's sensitivity to light. |
| **Filter** | Optical device used to modify transmitted light. |
| **Filter factor** | Number indicating the effect of the filter's density on exposure. |
| **Flare** | Unwanted light entering the camera and falling on film plane. |
| **Flash** | Mobile 5800K light source, high intensity, short duration. |
| **Floodlight** | Diffuse tungsten light source. |

| | |
|---|---|
| **Focal** | Term used to describe optical situations. |
| **Focal length** | Lens to image distance when focused at infinity. |
| **Focal plane** | Where the film will receive exposure. |
| **Focal plane shutter** | Shutter mechanism next to film plane. |
| **Focal point** | Point of focus at the film plane or point of interest in the image. |
| **Focusing** | The action of creating a sharp image by adjustment of the lens to film distance. |
| **Fog/fogging** | Effect of light upon unexposed film. |
| **Foreground** | Area in front of subject matter. |
| **Format** | Camera size, image area or orientation of camera. |
| **Frame** | Boundary of composed area. |
| **Fresnel** | Glass lens used in spotlight. |
| **Front light** | Light from camera to subject. |
| **Front standard** | Front section of large format camera. |
| | |
| **Gels** | Colour filters used on light sources. |
| **Genre** | Style or category of photography. |
| **Gobos** | Shaped cutters placed in front of light source. |
| **Grain** | Tiny particles of metallic silver or dye which make up the film image. |
| **Grey card** | Contrast and exposure reference, reflects 18% of light. |
| **Ground glass** | Viewing and focusing screen of large format camera. |
| **Guide number** | A measurement of the power of flash relative to the film speed being used. |
| | |
| **Halftone** | Commercial printing process, reproduces tone using a pattern of dots printed by offset litho. |
| **Hard/harsh light** | Directional light with defined shadows. |
| **High key** | Dominant light tones and highlight densities. |
| **Highlight** | Area of subject giving highest exposure value. |
| **Hot shoe** | Plug in socket for on-camera flash. |
| **Hyperfocal distance** | Nearest distance in focus when lens is set to infinity. |
| | |
| **Incandescent** | Tungsten light source. |
| **Incident** | Light meter reading from subject to camera using a diffuser (invercone). |
| **Infinity** | Point of focus where bellows extension equals focal length. |
| **Infrared film** | A film which is sensitive to wavelengths of light longer than 720nm that are invisible to the human eye. |
| **Invercone** | Trademark of Weston. Dome shaped diffuser used for incident light meter readings. |
| **Inverse square law** | Mathematical formula for measuring the fall-off (reduced intensity) of light over a given distance. |

| | |
|---|---|
| **Iris** | Aperture/diaphragm. |
| **ISO** | Film speed rating - International Standards Organisation. |
| **Keylight** | Main light source relative to lighting ratio. |
| **Laboratory** | Film processing facility. |
| **Landscape** | Horizontal format. |
| **Large format** | 5 x 4inch camera, 10 x 8inch camera. |
| **Latitude** | Film's ability to record the brightness range of a subject. |
| **Lens** | Optical device used to bring an image to focus at the film plane. |
| **Lens angle** | Angle of lens to subject. |
| **Lens cut off** | Inadequate covering power. |
| **Lens hood** | Device to stop excess light entering the lens. |
| **Light** | The essence of photography. |
| **Lightbox** | Transparency viewing system. |
| **Lighting contrast** | Difference between highlights and shadows. |
| **Light meter** | Device for the measurement of light. |
| **Lighting grid** | Studio overhead lighting system. |
| **Lighting ratio** | Balance and relationship between light falling on subject. |
| **Long lens** | Lens with a reduced field of view compared to normal. |
| **Loupe** | Viewing lens. |
| **Low key** | Dominant dark tones and shadow densities. |
| **Luminance range** | Range of light intensity falling on subject. |
| **M** | Flash synchronisation setting for flash bulbs. |
| **Macro** | Extreme close up. |
| **Matrix metering** | A reflected light meter reading which averages the readings from a pattern of segments over the image area. Bias may be given to differing segments according to preprogrammed information. |
| **Maximum aperture** | Largest lens opening, smallest f-stop. |
| **Medium format** | 6 x 7cm, 6 x 6cm, 6 x 4.5cm. |
| **Meter** | Light meter. |
| **MIE** | Meter indicated exposure. |
| **Minimum aperture** | Smallest lens opening, largest f-stop. |
| **Monorail** | Support mechanism for large format camera. |
| **Multiple exposure** | More than one exposure on the same piece of film. |
| **ND** | Neutral density filter. |
| **Negative** | Film medium with reversed tones. |
| **Negatives** | Exposed, processed negative film. |
| **Neutral density** | Filter to reduce exposure without affecting colour. |
| **Non-cord** | Flash not requiring direct connection to shutter. |
| **Normal lens** | Perspective and angle of view approximately equivalent to the human eye. |

| | |
|---|---|
| **Objective** | Factual and non-subjective analysis of information. |
| **Opaque** | Does not transmit light. |
| **Open up** | Increase lens aperture size. |
| **Orthochromatic** | Film which is only sensitive to blue and green light. |
| **Overall focus** | Image where everything appears sharp. |
| **Over development** | When manufacturer's processing recommendations have been exceeded. |
| **Overexposure** | Exposure greater than meter indicated exposure. |
| | |
| **Panchromatic** | Film which is sensitive to blue, green and red light. |
| **Panning** | Camera follows moving subject during exposure. |
| **Perspective** | The illusion of depth and distance in two dimensions. The relationship between near and far imaged objects. |
| **Photoflood** | 3400K tungsten light source. |
| **Photograph** | Image created by the action of light and chemistry. |
| **Plane** | Focal plane. |
| **P.o.v.** | Point of view. |
| **Polarising filter** | A filter used to remove polarised light. |
| **Portrait** | Type of photograph or vertical format. |
| **Positive** | Transparency. |
| **Preview** | Observing image at exposure aperture. |
| **Previsualise** | The ability to decide what the photographic image will look like before the exposure. |
| **Primary** | The colours, blue, green and red. |
| **Process** | Development of exposed film. |
| **Pull** | Under processing of film. |
| **Push** | Over processing of film. |
| | |
| **QI** | Quartz iodine light source. |
| | |
| **Rear standard** | Rear section of large format camera. |
| **Reciprocity failure** | Inability of film to behave predictably at exposure extremes. |
| **Reflectance** | Amount of light from a reflective surface. |
| **Reflected** | Light coming from a reflective surface. |
| **Reflectance range** | Subject contrast measured in even light. |
| **Reflection** | Specular image from a reflective surface. |
| **Reflector** | Material used to reflect light. |
| **Refraction** | Deviation of light. |
| **Resolution** | Optical measure of definition, also called sharpness. |
| **Reversal** | Colour transparency film. |
| **Rimlight** | Outline around a subject created by a light source. |
| **Rise** | A movement on large format camera front and rear standard. |

| | |
|---|---|
| **Saturation** | Intensity or richness of colour. |
| **SBR** | Subject brightness range, a measurement of subject contrast. |
| **Scale** | Size relationship within subject matter. |
| **Scrim** | Diffusing material. |
| **Secondary** | Complementary to primary colours, yellow, magenta, cyan. |
| **Selective focus** | Use of focus and depth of field to emphasise subject areas. |
| **Shadow** | Unlit area within the image. |
| **Sharp** | In focus. |
| **Shutter** | Device controlling the duration (time) of exposure. |
| **Shutter-priority** | Semiautomatic exposure mode.  The photographer selects the shutter and the camera sets the aperture automatically. |
| **Shutter speed** | Specific time selected for correct exposure. |
| **Side light** | Light from side to subject. |
| **Silhouette** | Object with no detail against background with detail. |
| **Slave** | Remote firing system for multiple flash heads. |
| **Slide** | Transparency usually 24 X 36mm. |
| **Slow film** | Low film speed rating. |
| **SLR** | Single lens reflex camera, viewfinder image is identical to film image. |
| **Small format** | 35mm. |
| **Snoot** | Cone shaped device to control the spread of light. |
| **Softbox** | Heavily diffuse light source. |
| **Softlight** | Diffuse light source with ill-defined shadows. |
| **Specular** | Highly reflective surfaces. |
| **Speed** | ISO rating, exposure time relative to shutter speed. |
| **Spot meter** | Reflective light meter capable of reading small selected areas. |
| **Spotlight** | Light source controlled by optical manipulation of a focusing lens. |
| **Standard lens** | Perspective and angle of view equivalent to the eye. |
| **Stock** | Chosen film emulsion. |
| **Stop** | Selected lens aperture relative to exposure. |
| **Stop down** | Decrease in aperture size. |
| **Strobe** | 5800K light source. |
| **Studio** | Photographic work-place. |
| **Subject** | Main emphasis within image area. |
| **Subject reflectance** | Amount of light reflected from the subject. |
| **Subjective** | Interpretative and non-objective analysis of information. |
| **Swing** | A movement on large format front or rear standards. |
| **Symmetrical** | Image balance and visual harmony. |
| **Sync** | Flash sychronisation. |
| **Sync lead** | Cable used to synchronise flash. |
| **Sync speed** | Shutter speed designated to flash. |

| | |
|---|---|
| **T** | Shutter speed setting for exposures in excess of 1 second. |
| **T-stop** | Calibration of light actually transmitted by a lens. |
| **Text** | Printed word. |
| **Thin** | Overexposed positive, underexposed negative. |
| **Thyristor** | Electronic switch used to control electronic flash discharge. |
| **Tilt** | A movement on large format front or rear standards. |
| **Time** | Shutter speed, measure of duration of light. |
| **Time exposure** | Exposure greater than 1 second. |
| **Tonal range** | Difference between highlights and shadows. |
| **Tone** | A tint of colour or shade of grey. |
| **Trace** | Material used to diffuse light. |
| **Transmitted light** | Light that passes through another medium. |
| **Transparency** | Positive film image. |
| **Transparent** | Allowing light to pass through. |
| **Tripod** | Camera support. |
| **Tripod clamp** | Device used to connect camera to tripod. |
| **TTL** | Through the lens light metering system. |
| **Tungsten** | 3200K light source. |
| **Type face** | Size and style of type. |
| **Typography** | Selection of type face. |
| | |
| **Under development** | When manufacturer's processing recommendations have been reduced. |
| **Uprating film** | Increasing the film speed. |
| **UV** | Ultra violet radiation invisible to the human vision |
| | |
| **Vertical** | At right angles to the horizontal plane. |
| **Viewpoint** | Camera to subject position. |
| **Visualise** | Ability to exercise visual imagination. |
| | |
| **Wide angle** | Lens with a greater field of view than normal. |
| | |
| **X-sync.** | Synchronisation setting for electronic flash. |
| | |
| **Zone** | Exposure system related to tonal values. |

# Other Titles in the Series

## Location Photography: Essential Skills
*Mark Galer*

This provides essential skills for photographers using 35mm SLR and medium format cameras working with both ambient and introduced light. Through a series of practical exercises the photographer is shown the techniques and design elements required to be able to communicate clearly and creatively. The basic essentials are described, from exposure, to framing the image and how to work with light and contrast.

**1999** • **192 pp** • **246x189 mm** • **Paperback** • **0 240 51548 X**

## Studio Photography: Essential Skills
*John Child*

This provides essential skills for photographers with medium and large format cameras working with tungsten and flash in a controlled environment. The photographer is guided through the use of studio equipment for a variety of different purposes.

With a strong commercial orientation, the emphasis is placed on technique, communication and design within the genres of still life, advertising illustration, portraiture and fashion.

**1999** • **192 pp** • **246x189 mm** • **Paperback** • **0 240 51550 1**